Art Stories

Giuseppe Pallanti

Mona Lisa Revealed
The True Identity of Leonardo's Model

Cover
Leonardo da Vinci, *Mona Lisa*
Paris, Musée du Louvre

Editor
Eileen Romano

Design
Marcello Francone

Copy Editor
Emanuela di Lallo

Layout
Antonella Arezzo

Translation
Timothy Stroud

First published in Italy in 2006
by Skira Editore S.p.A.
Palazzo Casati Stampa
via Torino 61
20123 Milano
Italy
www.skira.net

Printed and bound in Italy.
First edition

Distributed in North America
by Rizzoli International Publications, Inc.,
300 Park Avenue South, New York,
NY 10010
Distributed elsewhere in the world
by Thames and Hudson Ltd.,
181a High Holborn, London WC1V
7QX, United Kingdom

ISBN-13: 978-88-7624-659-3
ISBN-10: 88-7624-659-2

... attento qualiter
se gessit prefata domina Lisa
erga dictum testatorem
ingenue et tanquam mulier ingenua ...

(from the will of Francesco del Giocondo,
husband of Lisa Gherardini, 29 January 1537)

Contents

Foreword

Several years ago during research on farms in Chianti, I was struck by the name of a particular owner, Antonmaria di Noldo Gherardini, which I had come across some time earlier in a book on the history of art. I remembered that he was the father of Mona Lisa and so I began searching through the historical archives of Florence for any information I could find on the Gherardini and del Giocondo families.

I focused my investigation on three particular archives: first, Florence's Archivio di Stato, one of the most well-known internationally. It is a mine of information and an inexhaustible source for studying the history of Florence from the early Middle Ages. The Archivio di Stato holds the deeds of ancient city institutions, old books relating to churches and convents, and the private archives of many Tuscan families. One of its most famous registries is the Catasto, which contains the tax returns of Florentine citizens since 1427. It is an outstanding historical source due to the continuity and wealth of its data on the composition of families and distribution of property. Consisting of huge leatherbound paper registers compiled in handwriting very different to today's, study of these records has allowed the history of the families of Lisa Gherardini and Francesco del Giocondo to be pieced together, as well as the family they created together.

Another important register for the study of the daily life of the time is the Archivio Notarile that for more than one thousand years collected the deeds produced by the notaries of Florence and, therefore, all those major and minor facts that occur during the course of a lifetime. It is in this archive that the documentation was found, for example, of contracts, agreements and wills drawn up by the characters in this story.

The Archivio dell'Opera di Santa Maria del Fiore, which is stored close to the Duomo, contains extraordinary records on the liturgy, sacred music and construction of the Duomo, its dome and the names of children baptised there. Until fifty years ago, all Florentine babies were baptised in the Baptistery beside the Duomo, and the prelates in the Curia recorded each event in special registers. Painstaking examination of these handwritten records revealed the dates of birth of Lisa, Francesco, and their relatives.

The business records of the del Giocondo family were deposited in the Archivio Storico dell'Ospedale degli Innocenti, in a room that faces the entrance cloister of Brunelleschi's elegant building. This archive is particularly interesting on the subject of abandoned children and gives the visitor the sensation of going back in time due to its beautiful original furnishings and shelving which reaches from the ground to the vault of the frescoed ceiling.

I spent a long time in all three archives to be able to reconstruct the life of Lisa as a wife and mother, her husband's business dealings, the events that led to their marriage after the early death of Francesco's first wife, and the births of their many children. Among the most important documents was, first, Francesco's will, which reveals his love for Mona Lisa, his beloved wife, and second, the notarial deeds signed between the del Giocondo family and the father of Leonardo da Vinci, who was an established notary in late-fifteenth-century Florence.

In line with the claim made by Giorgio Vasari, the Italian sixteenth-century artist, architect and art historian, for centuries the painting known both as the *Mona Lisa* and *La Gioconda* has been considered the portrait of Lisa Gherardini, the second wife of Francesco del Giocondo. But the theft of the painting in 1911 and the press campaign that followed resulted in that attribution being queried, nourishing a debate that is still in progress. The painting was found in 1913 in a small boarding-

house in Florence and for two years it appeared regularly in the pages of international newspapers and magazines, acquiring a fame it had never previously known. In reaction to this excessive exposure, the image of Mona Lisa became the target of irreverent songs, satirical postcards and desecrating caricatures, like the famous one in 1919 by Marcel Duchamp who gave the lady a moustache and pointed beard.

In the wake of these events, historians debated the identity of the model. For some she was not Lisa Gherardini but another woman, or perhaps even an imaginary one. One of the first to contest Vasari's claim was André Charles Coppier, a famous engraver of *La Gioconda*. In an article published in January 1914, a month after the painting was found in Florence, he stated that the lady in question was not real, and that Leonardo had painted an idealized woman rather than an actual Florentine. In 1925 it was the turn of Adolfo Venturi, a highly regarded Italian art historian. Without mincing his words, and in complete contrast to Vasari, he declared that the woman in the picture could not have been a common woman, even if a rich one, as Lisa Gherardini had been, but must have been an Italian noblewoman, one whom he identified as Costanza d'Avalos, Duchess of Francavilla.

In the second half of the century other experts began to move away from Vasari's thesis, giving weight to the account provided by Antonio de Beatis, secretary to Luigi d'Aragona, the cardinal from Naples, who in 1517 visited Leonardo in France. De Beatis probably saw the painting and in his journal described it as the portrait of a Florentine woman commissioned not by Francesco del Giocondo, but by Giuliano de' Medici, who had been Leonardo's protector in Rome from 1513 to 1516. In making this claim, he effectively moved the date of the painting's execution back and invalidated Vasari's contention.

On the basis of Antonio de Beatis's testimony, in 1957 Carlo Pedretti identified *La Gioconda* as Pacifica Brandano, the

lover of Giuliano de' Medici in Rome, and in 1987 excluded the possibility that it might have been Lisa Gherardini. In 1977 the art historian Martin Kemp decided not to take any sides and simply called the painting *Portrait of a Lady on a Balcony*. Others have made other, audacious claims, for example, that it was actually a self-portrait of Leonardo in drag, supporting the notion of the artist's presumed homosexuality.

On the basis of the evidence and facts brought together here, some experts have recently formulated a new and substantially different thesis: that Leonardo made two copies of the famous portrait. One ended up in the Louvre while the other, described by Vasari, is to be found somewhere in the vaults of an international merchant bank. This is the hypothesis of the moment and, no doubt, will not be the last.

As a result of this long and controversial debate, two schools of thought have formed: one considers Vasari to have been correct in claiming that the lady in question was Lisa Gherardini, and the other maintains the opposite, affirming that the architect's assertion was unfounded. However, the testimonies and documents collected here seem to clarify the question, making it difficult—as we shall see—not to side with Vasari's supporters and the thesis in favor of Mona Lisa.

The characters in this story are Lisa, Francesco and Leonardo, and the setting is a city that still boasts, though to a lesser degree, the vitality and dynamism of the time when its economic and financial hegemony in Europe was unquestioned. In the fifteenth century Florence was still a rich city and the backdrop to cultural and artistic movements of international importance. The late Quattrocento and early Cinquecento represented the epilogue of the extraordinary Florentine Renaissance, when the human and professional events in the lives of Lisa, Francesco, and Leonardo took place. Though these three are the main characters, the scenario of Florence cannot be disregarded for an understanding of their story.

The book is in two parts: the first describes the political and social history of Florence; the second is a small fresco of daily life in Florence, in which the lives of the couple Lisa Gherardini and Francesco del Giocondo became entwined with those of famous residents in the city.

I have asked the advice and received the help of many people. In particular I would like to thank Alessandro Cecchi, Director of Medieval and Renaissance Painting in the Galleria degli Uffizi, a brotherly friend, an expert colleague in archival research, and an esteemed scholar of the Florentine Renaissance; Rab Hatfield, Coordinator of the Department of the History of Art at Syracuse University of Florence, and Anthony Molho, Head of the Department of History and Civilization at the Istituto Universitario Europeo. These three were among the first to read the manuscript and encourage me in its publication.

In addition, Franca Santini and Aldo Lurci, lecturers in the History of Art and artists themselves, who gave me valuable suggestions; Franco Franchi, a man of great culture; Giulia Michelini, who so carefully revised the original text; Riccardo Nencini, President of the Consiglio Regionale della Toscana; and my friends Paola and Roberto Mannini, and Mariella and Alessandro Poggesi, who always supported me.

I am also very grateful to all the staff in the Archivio di Stato in Florence, Lucia Sandri, the Director of the Archivio Storico dell'Ospedale degli Innocenti, and Lorenzo Fabbri, the Director of the Archivio dell'Opera di Santa Maria del Fiore, who were always willing to help me, even when I complicated their work.

Finally, though it was I who succeeded in bringing all this research to a conclusion, it was my nearest and dearest who for years have put up with my unpardonable seclusion and obstinate fixations: first and foremost, my wife Patrizia, a woman who, if there is a Heaven, has already won her place there, and

my children, Guido and Francesca, whom I have often neglected, choosing the flat, silent screen of the computer to their problems and smiles.

This new edition is due above all to Niccolò Rositani and Eileen Romano, who have taken this book to their hearts with enthusiasm and proficiency. To both, my warmest and sincerest thanks.

Part One

FLORENCE DURING THE RENAISSANCE

Florence in the fifteenth and sixteenth centuries. Aspects of political and social life

At the start of the Quattrocento Florence had a population of approximately sixty thousand and was one of the largest cities in Europe.[1] It reached its demographic and economic peak at the end of the Duecento and start of the Trecento, when the population numbered roughly one hundred thousand[2] and the gold florin, coined for the first time in 1252 and accepted by all as an international currency, circulated through the markets of half the world. After the plague, known as the Black Death on this occasion, visited the city in 1348, the population was drastically reduced, according to some estimates as much as 40–50%, to a level at which it remained throughout the following century.[3]

The city was governed by a Republic which, following the 1378 uprising by the wool-carders known as the Ciompi Revolt,[4] passed under the control of an oligarchy led by the Albizzi family. In consequence of the insurrection, new laws were approved that eliminated the artisans and small traders represented by the Arti Minori (minor guilds) and entrusted rule of the city to the members of the seven Arti Maggiori (major guilds). In this way, the power of the commune became the monopoly of a small group of Florentine families allied amongst themselves.

The Signoria represented the executive arm of the Republic and was led by a Gonfaloniere assisted by eight Priors, two for each of the four districts of the city (Santo Spirito, Santa Croce, Santa Maria Novella, and San Giovanni). Every two months the Priors and Gonfaloniere were chosen by lot from among those inscribed in the Guilds. As three-quarters of the names inscribed belonged to the Arti Maggiori, the major guilds were always better represented. The seat of government was the

Palazzo della Signoria, a massive stone building with the tall Arnolfo Tower that looked onto Piazza della Signoria.

In the late Trecento and early Quattrocento Florence was experiencing one of the most culturally intense periods of its history and became the cradle of Humanism in Italy.[5] Florentine Humanism was based on the secular vision of the world of the ancients and placed man at the center of the universe,[6] as much in philosophical discussions as in works of art. The initiative and financial success of the many businessmen sustained the humanist movement and boosted development of the arts and culture. Even public life was affected by this new climate: the Palazzo della Signoria became a center of the new thinking and the Chancellors of the Republic, such as Coluccio Salutati and Leonardo Bruni, were principally men of letters and politicians only second.

During this period great artists like Filippo Brunelleschi, Donatello and Masaccio[7] broke with the art of the past, abandoning the elegant stylizations of Gothic art. In the field of architecture they were inspired by the ideal harmony of the Classical world and focused on the relationships between proportions and different elements. In painting they experimented with a language that had as its goal the idealizing perfection of forms in the representation of space and the human figure. This was the time of great works of Florentine Humanism, like the Baptistery doors by Lorenzo Ghiberti, the dome of the Duomo of Santa Maria del Fiore and the Spedale degli Innocenti designed by Filippo Brunelleschi, the cycle of frescoes in the Brancacci Chapel by Masaccio and Masolino, and Palazzo Rucellai and the facade of Santa Maria Novella designed by Leon Battista Alberti.

The backdrop to this extraordinary cultural phase was the increasingly bitter clashes between the city's two political factions: the oligarchy in power led by Rinaldo degli Albizzi and the Medici faction led by Giovanni di Bicci. Bicci had not been born rich but became so through trade, and did not hide his

sympathies for the middle and lower classes[8] who played an important role in the life of the city.

Whereas the power of the Albizzi faction rested on a series of alliances with the aristocratic families in Florence, the Medici drew their strength from their numerous business affairs. They were members of many trading companies (in particular one involved in the wool trade); they were heavily involved in banking activities that affected not only Florence but also Rome and major European cities; they had an extensive network of commercial contacts and, moreover, benefited from important political support abroad. The combination of these strengths was decisive and enabled them to win and consolidate power in Florence.[9]

One of the most heavily debated issues was tax reform. Until that time the Republic's revenue was created by a myriad of indirect taxes, as diverse as they were inconsistent in their yield, that weighed particularly heavily on the lower classes. At moments of greatest need the Republic turned to *prestanze*, forced loans that constituted State securities and which had become a formidable means of enrichment for the great families of Florence.

With the approval of Giovanni de' Medici, in 1427 a new tax system was introduced that ensured a more regular flow of revenue and which also affected those of large fortune. This was the famous Florentine Catasto, a tax system that introduced direct tax on all incomes whether they derived from personal assets or real estate. Every citizen had to present a declaration (known as a *portata*) of his current credits and debits, fixed assets and their yield (excluding the house he or she lived in), and an indication of the *bocche*, the composition of the family, as each head represented a reduction in the tax paid.

The Catasto of 1427 provided an extraordinary means of understanding how ownership of the countryside around Florence was structured; several decades ago Elio Conti was one of

the first to study this systematically. He discovered that at the start of the Quattrocento 70% of the land belonged to city-dwellers, 20% to the Church,[10] and less than 10% to the farmers. This distribution was the result of changes in landed property that had begun much earlier with the dissolution of the feudal system and consequent dynamic development of urban centers, as a result of which cities won back their political supremacy. They extended and strengthened their control over the countryside when the merchant classes began to invest in land to protect themselves against the risks of trade and for reasons of social prestige. The effect was the progressive concentration of land in the hands of the city-dwellers, often at the expense of the small-holders.

During the Duecento the phenomenon was probably accentuated, and by the end of the Trecento the hills of central Tuscany had been organized on the model of the sharecropping estate. This system was founded on compact individual properties (the holding) and a contractual practice based on the co-partnership of workers (the sharecroppers). As is known, this model became widespread in the Florentine area and remained current until the mid-twentieth century. It had a deep impact on social relations in the countryside and contributed decisively to the definition of the agricultural landscape.

Florence has always had strong links with the countryside: many of its families originated there and often owed their political fortunes to their estates. All the ancient charitable institutions and many monasteries and convents owned farms with which they were in daily contact, as they provided an essential source of income and provisions. Moreover, a property in the countryside carried with it a social cachet, particularly for the new rich, in addition to its economic importance. For many it was a sign of social distinction, one to draw attention to in certain circumstances, such as civil or religious festivities or, more concretely, at the conclusion of business affairs.

Two years after the new Catasto was approved, Giovanni de' Medici died and leadership of the household passed to his son Cosimo. Cosimo was an outstanding figure in the long history of the dynasty and would play a decisive role in the winning and consolidation of the family's political power. In the meantime the conflict between the Albizzi and the Medici intensified with, in 1433, a temporary shift in favor of the former when Cosimo was arrested, imprisoned in a cell in the Palazzo della Signoria, and then exiled to Padua. However, within a year the situation had turned around and, with the help of Venice, Cosimo returned to Florence in 1434 and forced the Albizzi into exile.[11]

This event was decisive for the history of the city. On one hand it marked the end of the ancient Republic, including the oligarchic type; on the other it determined the advent of the seigniory and the rule of the Medici, which was to last, through its various vicissitudes, for almost three centuries until the early years of the eighteenth century. Cosimo exercised his power discreetly, preferring to act behind the scenes, and almost never took on institutional roles. Through the men whom he trusted he always held control of public life in Florence and, when foreign ambassadors and correspondents arrived in the city, they would first visit Palazzo Medici, the family's private residence in Via Larga (today Via Cavour), and only then pass to Palazzo Vecchio.[12] Furthermore, Cosimo was the head of a very large business that he never neglected; he was a great patron of the arts, and such was his diplomacy and international friendships that he managed to arrange for the 17th ecumenical Council to be transferred from Ferrara to Florence in 1439, where it was held in the church and convent of Santa Maria Novella. Prudent in domestic affairs, in his foreign policy Cosimo was more open-minded and engineered a radical change in Florence's long-established alliances: in the middle of the century, afraid of the Serenissima's expansionistic aims in northern Italy during the conflict between Milan and Venice, he supported his friend

Francesco Sforza, Duke of Milan, whose military campaigns were financed by the Medici bank.

As is to be expected in such cases, reprisals were not long in coming. Venice broke off its traditional friendship with Florence and allied itself with the king of Naples. In 1452 Venetian troops moved against Milan while those of Naples attacked Florence. The Aragonese army first occupied the Chiana valley and then headed towards the hills of Chianti. It besieged Castellina but did not succeed in taking the town, though it spread destruction in the surrounding countryside. This was the first Aragonese invasion of Chianti; a second, perhaps even more ruinous, took place twenty-five years later.

Cosimo de' Medici was an important statesman, both internally and in his dealings with other States in Italy, and when he died in 1464 his succession created problems. The reins of government in the family, its business affairs and the State were passed to Cosimo's son Piero, who was less able than his father in matters of politics and, moreover, in poor health. His nickname was 'il Gottoso' (the Gouty), though this condition was common in the Medici dynasty.

Two years after Cosimo's death several important Florentines—such as Luca Pitti, Agnolo Acciaiuoli, Niccolò Soderini, and Dietisalvi Neroni—secretly contacted the Venetians and in 1466 attempted to raise an armed revolt. However, as this was unsuccessful and the leaders arrested and sent into exile, the Medicis' subsequent repression only served to strengthen their seigniory.

Piero died in 1469, leaving the handling of the affairs of State and business in the hands of his two sons Lorenzo and Giuliano. Lorenzo was a man of great qualities: highly intelligent, politically aware and with outstanding abilities as a mediator, he soon proved himself a fine and able diplomat (Guicciardini called him "the needle on the scale" of the Italian political world) and was considered by some to be Cosimo's nat-

ural heir and one of the shrewdest political men of his time. When he was just twenty years old, Lorenzo was made head of the Florentine State and in a short time took absolute power by radically changing the election mechanism for the Seigniory so that only complaisant Priors were returned. Unlike his grandfather, who had lived in a simple manner, Lorenzo il Magnifico liked the pleasures of life, festivals and knightly tournaments; he was a passionate follower of the arts and literature, a writer and poet himself, and welcomed the greatest artists of the moment to his court.

The cultural climate in Florence in the Quattrocento was also the result of a successful economy in all business sectors. The city as a whole was rich and this was reflected in the manner of living: it required larger, more comfortable houses and works of art that demonstrated the personal success and social prestige achieved by many families.[13] During the century there was heavy investment in public and private construction, resulting in impressive new buildings[14] and the renovation of the city's medieval tower-houses. After the plague of 1348 the population of Florence was dramatically reduced but did not increase during the Quattrocento: consequently there was no shortage of housing, but a demand ensued for larger, more comfortable buildings with different characteristics. Florence was compact, split in two by the river Arno and further divided by a network of small streets based on the city's ancient Roman layout. The houses were mostly tall and narrow and crowded up against one another, but the new Renaissance palazzi were wider and more elegant. Standing over them were medieval towers, churches, monasteries, and convents, which were present in each district of the city. The sumptuous, more spacious houses of the well-to-do contrasted with the narrower, more modest dwellings of the ordinary folk. Large families were obliged to live together and share their limited space between different generations.

Fifteenth-century Florence was a city of merchants, ecclesiastics, artists, and craftsmen, but also of the poor and outcasts whose lives revolved around gambling and vice and were punctuated by violence and discrimination. The society of Florence during the Renaissance was not idyllic, as has often been thought, and contained huge inequalities and contrasts; for many life was hard and of little value.

In the streets one would come across idle aristocrats, rich merchants, enterprising bankers, hardworking craftsmen, small-time dealers and shopkeepers who for the most part enjoyed a comfortable or at least decent life. Every morning a phalanx of lawyers and notaries arrived at the Palazzo del Podestà in Via Ghibellina to attempt to resolve the unending legal disputes that were their source of wealth and social prestige. Each day a large number of priests and bishops, monks and friars flapped their way between the city's churches and monasteries where they would pray but also eat well.

In addition to these privileged classes were the poor and the misfits who had difficulty in making ends meet and who were obliged, for reasons of survival, to indulge in conduct of dubious legality. It was not unusual to come across men who had fled their homeland or young female slaves from Serbia, the Orient or Africa, who had been bought by rich Florentines for their services of one kind or another. The streets were home to the many unfortunates who could not have survived if they had not been helped by the ancient institutions of the city, such as the confraternities that had long been rooted in the city fabric. Each district of Florence had a street reserved for prostitutes, both male and female; rape of children and women and sodomy were not rare, at least to judge by the reports send to the Uffiaciali dell'Onestà, the magistrates whose task was to maintain good conduct.[15]

The world of prostitution was dominated by intrigue, abuse of power and perverse dealings that revolved around

man's basest instincts and sometimes resulted in acts of violence. Many of the women came from elsewhere, such as northern Italy and other European countries, as is clear from their names: Angela Teutonica Femina, Lucrezia la Veneziana, Barbara da Mantova, Lisabetta la Spagnola and Caterina di Schiavonia. In general their clients were not to be trusted and the women were made to suffer all kinds of humiliation. Exhausted and in poor health, they aged quickly and badly; if so, they would be given humiliating nicknames, as in the case of one woman whose body was in poor condition: named Maddalena, she was known to all as "la Baracca" (the Hovel).

There were also high-class prostitutes with a distinguished clientele, like the lovely Masina who received men and their confidences with grace and discretion. She exercised her profession among men of the Palazzo and was therefore well informed on matters of State. One evening in July 1510, she was stopped by the Ufficiali dell'Onestà but during her interrogation the guards were so astounded and intimidated by her knowledge of high-flown affairs[16] that they quickly let her go.

In gambling houses blows would be exchanged over the simplest argument, and a lost game or unpaid debt could lead to a stabbing or mortal injury. Despite the army of priests, monks, and nuns in the city, there was little fear of God and it was not abnormal for a priest to travel armed, to practice usury and come to blows with his debtors, nor to have sexual relations with prostitutes or even married women, and even with defenceless children.[17]

Justice was meted out severely but was not feared. There were different types of punishment and these were in proportion to the gravity of the offence committed. Socially dangerous crimes, such as sexual and physical violence, were usually punished with the expulsion of the guilty party from the city and the obligation to remain away for a certain number of years, perhaps even permanently.[18] Often exile was preceded by a ritual of

public humiliation whose form and intensity varied with the offence. In some cases the offender would be slapped in the pillory in the Bargello's inner courtyard for an hour or more, with an iron collar around his or her neck.[19] In other cases, he would be made to wear a two-pointed hat with two stoles that fell down over the shoulders like a bishop's mitre, hold a broom handle in one hand, and be placed on a donkey inside the Palazzo del Podestà.[20] Then the animal would be led by guards through the streets of the city center to the jeers of the public as far as the column in the market place, today Piazza della Repubblica.[21] Surrounded by this time by a noisy crowd, the humiliation was concluded in a spectacular manner: the offender was made to get off the donkey, tied up and whipped with a leather strap. Ten, fifteen or even twenty lashes would be given, lacerating the skin and leaving permanent scars. Occasionally the punishment would be even crueler, with slices of the ears and nose being taken off, the tongue damaged or the ears being completely cut off and sealed up.[22] For more serious crimes, such as rebellion and murder, the condemned would be hung from the windows of the Bargello or beheaded in the inner courtyard, though sometimes the execution could be avoided by the payment of a hefty sum by the prisoner's family.

Above the poor wretches at the bottom of Florentine society there was a wealthier class made up of artisans, manufacturers of high-quality fabrics, those who produced or sold food and clothing, others in what today would be called the service industry, and those who worked in artists' commercial workshops.

Today a famous source of general information on Florence is the chronicle written during the age of Lorenzo il Magnifico by Benedetto Dei, a business agent of the Medici family. Dei had traveled the world and in 1472 described his city in a detailed, enthusiastic manner: to him Florence was made beautiful by the palazzi inside the city walls, the country villas, the more than 100 churches and many convents, the 50 city squares

where the citizens worked and entertained themselves, and the many workshops that drove the city's dynamic economy. On these subjects he wrote with fervor but also to the point of exaggeration.

"Our beautiful Florence contains within the city two hundred seventy shops belonging to the wool merchants' guild, from whence their wares are sent to Rome, the Marches, Naples, Turkey, and Constantinople.

It contains three rich and splendid warehouses of the silk merchants' guild, and furnishes gold and silver stuffs, velvet, brocade, damask, taffeta, and satin to Rome, Naples, Catalonia, and the whole of Spain, especially Seville, and to Turkey and Barbary. The principal fairs to which these wares go are those of Genoa, the Marches, Ferrara, Mantua, and the whole of Italy; Lyons, Avignon, Montpellier, Antwerp, and London.

The number of banks amount to thirty-three; they have a counter and carpet outside and change money for the Levant and Ponent ... and for all the places in the world where money is used and changed.

The shops of the cabinet-makers, whose business is carving and inlaid work, are eighty-four; and the workshops of the stonecutters and marble workers in the city and its immediate neighborhood, fifty-four. Seventy is the number of the butchers, besides eight large shops in which are sold fowls of all kinds, as well as game ... and the native wine called Trebbiano, from Castello San Giovanni which would awaken the dead.

There are forty-four goldsmiths' and jewelers' shops, thirty gold-beaters, silver wire-drawers, and a wax-figure maker ... Go through all the cities of the world, nowhere will you ever be able to find artists in wax equal to those we now have in Florence.

Our beautiful city has twenty very worthy things to show to visitors, provided they not be important people, herders or soldiers, but they should be people of intelligence. First there is the belltower, second the cathedral, third the huge cupola, fourth the lovely palaces, fifth the paved roads, sixth the Annunziata, seventh the hospital, eighth the river, ninth the Santo Spirito and Santa Croce and Santa Maria Novella and cloisters and dormitories and San Lorenzo and the

Walls and the Capitolo de' Pazzi and the tombs of the Medici and Rucellai and a thousand other wonders that make the city a new Rome."[23]

In 1478, six years after Benedetto Dei described the city in his chronicle, Lorenzo de' Medici had to deal with the Pazzi Conspiracy, which caused upheaval in the city and sorely tested his power. The conspiracy was an attempted coup d'état by means of the simultaneous murders of Lorenzo and Giuliano de' Medici. Originating in the Vatican court and backed by the pope, and with the support of several families in Florence, the Pazzi and Salviati family devised a plan to kill the Medici brothers on Sunday 26 April, 1478, during Mass in the Duomo. At the sound of the Sanctus, Giuliano was stabbed and died on the instant, while Lorenzo was injured but managed to flee. Shortly afterwards violent reprisals were undertaken: several of the leaders of the conspiracy were hung and their bodies dangled from the windows of the Palazzo Vecchio, while others were followed and killed in the streets by citizens who supported the Medici family.

Although the attempt had failed, the pope did not give up. Still with the intention of overthrowing Medici power, he instigated an alliance between the king of Naples and the Sienese against the Florentines. Twenty-five years after its first occupation of Chianti, in August and September 1478 the Aragonese army invaded a second time, brought down the defences of Castellina and the following summer flooded through the Val d'Elsa to the hills of Florence. Just at the moment in which the city seemed doomed, Lorenzo revealed his diplomatic skills and made a daring move: he went to Livorno and took ship for Naples to meet King Ferdinand of Aragon in person. Once in the city he was made to wait for a long time for his meeting but, unexpectedly, he succeeded in establishing peace and winning a favorable agreement for Florence.

With the power of the Medici re-established, the city underwent a second artistic flowering and towards the end of the

century a new generation of artists achieved the highest point of the Florentine Renaissance, but they went further and heralded the art that was to flourish during the Cinquecento. This generation was composed of such artists as Botticelli, Leonardo da Vinci, Michelangelo and Raphael who, at the start of the sixteenth century, were all working in Florence. Each developed perspective and the formal perfection of the early Renaissance in his own manner: Leonardo with the use of light and sfumato, Michelangelo with vigorous plasticism and the centrality of the human figure, and Raphael by creating ideals of beauty, grace and stylistic elegance. Raphael went to Florence as a young man specifically to learn the techniques of portraiture from Leonardo.

To the general dismay of the Florentines, on 8 April 1492 Lorenzo the Magnificent died in his majestic villa in Careggi, making political life in Florence more complicated and unstable. He was succeeded by his son Piero but the young man was inferior to his father both in his personal capabilities and personality, nor did he enjoy a good reputation. Furthermore, his task was rendered more difficult by another factor: Lorenzo had not been a good administrator and had left the coffers of both his family and the State burdened with debts. Hardly two years later, when Charles VIII of France wished to pass through Tuscany with his army to reach Naples, Piero acceded to the French king's request but the Florentines rebelled against him for this and Piero and the Medici family were obliged to flee the city in secret.[24]

The power vacuum created by the removal of the Medici opened a new political phase, though one of brief duration. It was marked by repeated clashes between the Medici faction and the followers of the friar Girolamo Savonarola, who railed against the corruption of the Church and the arrogant behavior of the Medici State.

Fra' Girolamo began his monastic life in Bologna in 1474 and moved to the Dominican monastery of San Marco in Flo-

rence in 1482 after his theological studies in Ferrara had ended. From the pulpit of the famous church in Florence he began a vigorous campaign against the dissolute life of the clergy, invoking the punishment of God and predicting biblical disasters. Nor did his moralizing spare the rulers of the city, their abuse of power and the tyranny of the Medici family. In short time his friendship with Lorenzo developed into open hostility on account of the Medicis' undemocratic methods of government. When the family was chased out of the city in 1494 Savonarola himself assumed the political rule of Florence and became one of the principal advocates of the return to the republican form of government that had preceded the seigniory of the Medici. Undoubtedly the friar had a strong influence on proceedings and the hearts and minds of the Florentines, however, the importance of his role should not be exaggerated because the desire to reinstate the Republic and broaden public participation in government were already widespread in the city. For some time much of the city had been on a collision course with the Medici and their authoritarian methods, in particular against the system introduced by Lorenzo for control of the candidatures and the electoral system. And the revival of the alliance with the French represented continuity with the period of republican rule, when friendship between the two States was unquestioned.

With strong support from the public, Savonarola succeeded in changing much of the legislature in short time. He adopted an important series of measures, some of which were against usury and luxury; he had new rules approved and a reform of the tax system in 1495. The ancient Catasto, which had been substantially a declaration of income, was replaced by the Decima repubblicana which, so as not to affect trade negatively, introduced a tax on income earned from property.[25]

Yet the principal target of Savonarola's preaching was the Church and its lax morals. He never missed an opportunity to

denounce the corruption of the clergy, often with apocalyptic tones, thus bringing down upon himself the anger of the ecclesiastical hierarchy and excommunication from the pope. However, Savonarola's political plans met with failure and he came to a tragic end: accused of heresy, he was arrested, hung and burned at the stake in Piazza della Signoria on 23 May 1498.

The republican phase continued after Savonarola's death and in 1502 Pier Soderini was elected to the position of Gonfaloniere for life. It was under his government and in the political climate of those years that Michelangelo was commissioned to produce a sculpture of *David*, a powerful image of a people proud of its autonomy. Soderini remained at the head of the fragile Republic until 1512, during which time he was assisted closely on foreign affairs and military questions by Niccolò Machiavelli,[26] one of the most intelligent men of the era. In just a short period, Machiavelli went on many diplomatic missions, as a result of which he gained enormous experience on international relations and direct knowledge of the institutions and government practices of other States. For instance, in 1501 Machiavelli was sent to the court of Louis XII of France and a year later visited Cesare Borgia, known as Duke Valentino, at the time he was reorganizing the papal army and military defences with the help of Leonardo da Vinci.

Soderini's republican government proved weak and inadequate to deal with events and when, in 1511, Florence lost the support of the French, his end was already marked. The conflict between the French on one side and the pope and Spanish on the other, the pressure and the plots to restore the Medici to power in Florence, and Soderini's own indecision precipitated the situation: consequently, with the help of Spanish soldiers the Medici were returned to power in the city in 1512. Soderini fled to Rome, and Machiavelli, despite being confirmed in his post, was deposed, accused and tried for corruption. In the end he was forced to leave Florence and reside at the Albergaccio, his

country house in Sant'Andrea in Percussina, where he wrote his two masterpieces, *The Prince* and *The Discourses*.

During their exile from Florence between 1494 and 1512 the Medici had lost much of their prestige but linked their fortunes to those of the papacy. Fortunately for them, two of the popes at the start of the Cinquecento were members of the family: Giovanni, son of Lorenzo il Magnifico, became Leo X from 1513 to 1521, and Giulio, son of Giuliano murdered in the Duomo in 1478, was Clement VII from 1523 to 1534.

Thanks to these two, the Medici mended their political and economic fortunes and in 1512 even took back possession of their palazzi in Florence, though this was only a temporary state of affairs because in 1527 they were once again obliged to flee. Clement VII had allied the papacy with the French, which led to the Spanish under Carlos V marching into Italy and sacking Rome. At the same time a public uprising in Florence chased the Medici out again in an attempt to restore the Republic and government by the people. The leaders of the revolt even turned their opposition on the emperor. Carlos V immediately reacted and, this time in league with the pope, moved against Florence and besieged the city for almost a year. Despite valorous resistance and several heroic episodes, the city surrendered in August 1530 and the Medici were once more returned to Florence where they remained the unchallenged rulers until the early eighteenth century.[27]

Consequent upon strong rivalry and the lack of an outstanding figure in the Medici family, several years were needed to find a new head of government. It was only in 1537, after the assassination of Alessandro, that the young Cosimo I, son of Giovanni delle Bande Nere and Maria Salviati (a granddaughter of Lorenzo il Magnifico) was made Duke of Florence. Cosimo introduced important institutional reforms,[28] radically modified the existing ones, concentrated power in his own hands and installed an authoritarian regime. In 1555 he realized one of

his dreams, the conquest of the State of Siena,[29] and in 1569 was made Grand Duke of Tuscany by the pope.

With the enlargement of the State, Cosimo I pushed his bureaucratic reorganization forward and in 1560 appointed Giorgio Vasari, the court architect, to design and build the Uffizi, the large building that was to accommodate all the administrative offices of the Grand Dukedom.

To create this project, Vasari reorganized an important area of the city between Piazza Signoria, the river Arno and the Ponte Vecchio where buildings of great historical interest stood. His design and supervision of the construction of the new Uffizi were speedily and skilfully completed.

Also at the request of the Medici, he rebuilt the Sala del Maggior Consiglio and built the current Salone dei Cinquecento, named for the five hundred people it could accommodate. Other impressive works were carried out between 1563 and 1565: the Salone was heightened and given an opulent wooden ceiling, and the walls were decorated by painting over Leonardo da Vinci's fresco of *The Battle of Anghiari*, which was probably seriously damaged and perhaps even unfinished.

Vasari worked in Florence, Arezzo, Venice, and other Italian cities, and became a leading figure in the Italian Cinquecento as an architect and painter. The large frescoes in the Salone dei Cinquecento bear witness to his excellent pictorial technique. He was also the first art historian in the modern sense of the term, the first to document artists systematically, even if with some degree of inaccuracy. His book *The Lives of the Most Eminent Italian Architects, Painters and Sculptors*[30] was published in 1550 to great success and still today is an extraordinary source of information on the lives and works of artists from Cimabue to Michelangelo. He was also the first to describe in detail the painting *La Gioconda*, considered the portrait of Mona Lisa Gherardini, the wife of Francesco del Giocondo.

Part Two

MONA LISA

Lisa Gherardini's family

Lisa Gherardini was born in Florence on 15 June 1479 in a house in Via Maggio[1] which her parents had rented from the Corbinelli family[2] a few years earlier. It stood close to Borgo San Iacopo and the banks of the Arno. Lisa's father was Antonmaria Gherardini, who descended from a family long established in Chianti. At the time he was thirty-five years old and on his third marriage. In 1465 he had married Lisa Carducci and in 1473 Caterina Rucellai, but both had died in childbirth; in 1476 he married again, to Mona Lucrezia, the daughter of Piera Spinelli and Galeotto del Caccia.[3] The Del Caccia family was also originally from Chianti and had many properties in Val di Greve near the castle of Montefioralle.[4] In addition, like every noble house, they also had an aristocratic townhouse in Florence, on the corner of Via Ghibellina and Via de' Buonfanti, near to which the family of Lisa Gherardini moved in 1494.

Lucrezia was much younger than her husband Antonmaria and, in 1479, had only just turned twenty-four. This was her first pregnancy and, during the night of Tuesday, 15 June, felt her first labour pains, making all her relatives and women assistants anxious for her safety; however, towards midday, to the great relief of everyone, Lucrezia gave birth to a girl without complications. Perhaps the father would have preferred a boy but he could never have imagined the fortune and fame that this birth would have for himself and his family.

After the birth and the accompanying worry for the health of the mother (haemorrhages and infections were frequent and often fatal), the house began to bustle once more, the customary visits of well-wishing took place, and the Gherardinis invit-

ed everyone to the baptism a few hours later. As was tradition-
al until just fifty or so years ago, all newborn babies in Florence
were taken straightaway to the Fonti di San Giovanni for fear
that the baby would be whisked off back to Heaven by some
commonplace sickness. Lisa was washed and bound up tightly
in the belief, then very widespread, that this would positively in-
fluence her growth. She was dressed for the ceremony and in
the afternoon her father took her to the Baptistery with his re-
lations and friends. The little procession moved down Via Mag-
gio, turned into Borgo San Iacopo, crossed the Ponte Vecchio,
and headed up Via Por Santa Maria where the Giocondo fam-
ily had a shop. Francesco del Giocondo, then fourteen years
old, was at that time an apprentice there and may well have
seen the joyful procession passing by. At the Duomo they
passed through Lorenzo Ghiberti's bronze Porta del Paradiso
(the name supposedly given by Michelangelo to the entrance to
the Baptistery) and entered Dante's "bel San Giovanni". At the
font the baby girl received the signs of her first Sacrament with
seven other babies. As was conventional then, she was given two
names, Lisa and Camilla, the second of which would strangely
recur in her life.

Lisa was born during wartime and in a critical period for
the Republic of Florence. A year earlier the Pazzi Conspiracy
had taken place. A few months later the Aragonese army in-
vaded Chianti and in the following year moved down the
Valdelsa to the hills of Florence. The war of 1478–79 caused
great destruction, as a result of which Noldo and other
landowners insistently asked the officials in the Catasto for a re-
duction in their taxes as: "because of the war, our houses have
been burned, our possessions smashed and our workers and
livestock lost".[5]

Shortly before Lisa's birth, her grandfather Noldo had
died, leaving Antonmaria several farms in Chianti, some of
which had been owned from the early Quattrocento, like the

houses and land in Cortine near San Donato in Poggio. Born in 1402, Noldo had been the son of Antonio, the grandson of Arnoldo di Ugolino, and belonged to one of the many branches of the ancient Gherardini dynasty that had at one time been the lords of Val di Greve and Val d'Elsa.

At the start of the Quattrocento some of the family had been large landowners in the court of Poggibonsi, others on the Barberino side, while another branch of the family lived at Montefioralle above Greve.[6] They owned a number of properties, one of which was the large farm at Vignamaggio that lay in the splendid natural hollow between Greve, Lamole and Panzano. Later the family probably went into decline as in March 1422 Amadio del Pelliccia Gherardini (the owner of Vignamaggio at the time) was obliged to sell the farm to a rich family from Florence—the Gherardi[7]—who were cloth merchants but also enterprising ship insurers and business partners of the Medici.

In 1427 Noldo and Piero were two young bachelors just turned twenty. They lived in Chianti and still had no house in Florence. They had no employment (or did not declare one) and lived off their rents. From their father Antonio they had inherited various properties in Chianti: land and houses in Cortine, a small hamlet on the road between San Donato in Poggio and Castellina where they had a fine farm and their aristocratic house, and other smaller properties.[8] Overall Noldo's properties amounted to a respectable estate and the Catasto attributed to him an income that would provide him with a comfortable life, though nothing more.

Between 1451 and 1455 Noldo acquired other farms in Chianti, though we do not know where his money came from to pay for them, given that in his earlier tax declarations he did not enter any income other than his land rents which were insufficient for the purpose. He first bought the other half of Cortine, near San Donato in Poggio, from his brother Piero, plus two large farms, one called Selvoramole and the other San Silvestro,

and a small one.[9] And near Reggello in Upper Valdarno he purchased Chiesimone farm which, on his death, he instructed to be left to the hospital of Santa Maria Nuova.

By 1458 Noldo was a mature man and had married Lisa (whose name was given to their granddaughter) by whom he had two girls and two boys—Lucia, Ginevra, Antonmaria and Giovangualberto. He moved to Florence to a house situated in Via del Fondaccio,[10] today Via Santo Spirito. Like all country gentlemen, Noldo remained very attached to his land and always gave precedence to his country holdings over those in the city when making management decisions. Thus he never owned a home in Florence but rented from other people, moving several times.

Actually, Noldo had bought a house in Florence around 1465 but it was half ruined, as his son said.[11] It stood in a narrow street called Parione Vecchio (today Via del Purgatorio), which was a small, closed street leading to Piazza Rucellai. Here there was a wool-cleaning facility belonging to the Sernigi family that produced an awful smell through the whole building. As the place was unattractive and the house rundown, Noldo and his family lived there a short time and, after his father's death, Antonmaria moved to Via Maggio on the other side of the Arno, into the palazzo belonging to the Corbinelli family where, some years later, Mona Lisa was born.

Noldo died shortly before becoming a grandfather, not in his bed or even the intimacy of his house, but in the hospital of Santa Maria Nuova, the traditional place for cures or, more often, where the sick passed away. We do not know how an old man like him ended up in such an unhealthy institution, where beds were often shared. What is certain is that his son Antonmaria had him taken there, though whether due to a serious sickness or lack of care by his family we cannot know. Before dying Noldo made a will in which, as a mark of gratitude and an attempt to save his soul, he left his Chiesimone property to

the hospital[12] while all his other possessions were made over to his eldest son Antonmaria.

Noldo had hardly had time to dictate his last wishes before the Aragonese army invaded the countryside of Chianti and laid waste his farms in San Donato. The destruction caused by the raids were described in the report presented to the Catasto by his son in 1480.

At the time Antonmaria was living in the house in Via Maggio as the house in Parione Vecchio was still a ruin. Antonmaria was thirty-five and claimed that he had no income-yielding activity. He was married to the much younger Mona Lucrezia, the mother of baby Lisa who had no income-bearing dowry. The fact that the young girl did not yet have a dowry was very indicative of her parents' financial situation: in rich families a sum of money would generally be set aside on a girl's birth to assure her of a good marriage.

The Aragonese raids were a hard blow to his properties and Antonmaria described the farms in Chianti left to him by his father to be in a state of abandon. For love of war, he declared with a certain sarcasm, I have not earned anything from them. The farm in Cortine had been wrecked and Selvoramole and San Silvestro had had their fields ruined, houses broken into and sheds burned down.[13]

But like his father, Antonmaria had a strong and proud nature. Instead of allowing himself to be distressed, he reacted by renting several nearby farms belonging to the Santa Maria Nuova hospital, which had also suffered during the war. The largest had a lovely house with an attractive tower and annexe, and for this reason it was called La Casa in Pesa or, more simply, La Casa. In addition to this, the hospital also rented Antonmaria the farms of San Leonardo, Carobbio and Pretazzo, which were situated beside one another, for five years.[14]

Ca' di Pesa, as it is called today, lies in a landscape of rare beauty in the heart of Chianti on the slopes of the hill that runs

down from Panzano Castle to the river Pesa. The house and annexes look out like a large balcony onto the valley below, offering an all-round view onto the splendid rural landscape of Chianti. Interlacing white roads across the hills connect the historical farmhouses, small fortified hamlets, and lovely Romanesque churches that stand in a setting of great harmony, one that man has successfully created and, fortunately, also conserved.

Ca' di Pesa is a complex construction composed of sections added at different times. Its original core is a massive stone building that was originally part of ancient Roffiano Castle, which was several times mentioned in parchments of the twelfth and thirteenth centuries, but it was the theater of repeated military clashes that brought about its ruin. With the dissolution of the feudal system, cities once more took control of their land, local defence requirements diminished and the old military towers were turned into farmhouses. A similar fate occurred to the Roffiano fortifications when they were turned into farm buildings.

At the start of the Cinquecento, Ca' di Pesa was composed of the proprietor's house, the building that provided the peasants' accommodation, several animal stalls, a large wine cellar, an olive mill, a bread oven, cheese rooms, and several sheds to store the farm equipment.[15]

Around the farmhouse lay the irregular fields, shaped to fit the lie of the land. Rows of vines and olive trees alternated between the strips of land sown with wheat, which was at that time the principal crop. The woods consisted mainly in oaks, Turkey oaks and ilexes, with the tips of a few green pines or darker cypresses rising above them. The undergrowth was composed of juniper and broom which flower at the end of May, creating joyful yellow patches that signaled the imminent arrival of the hot weather.

Mona Lisa used to stay in the house when her father moved the family here at the start of summer. Like all the own-

ers, Antonmaria wanted to be present during the wheat harvest in June and July, in order to check the operations and divide the crops evenly with the sharecroppers. Harvesting wheat was one of the most physically demanding tasks and the peasants were obliged to work all day under a burning sun; but it was also a festive time with songs and dances held in the evenings in the farmyard. These were carefree times in which young love would bud, but also occasions to consolidate and hand on the ancient peasant culture.

The renting out of the Chianti farms belonging to Santa Maria Nuova did not come about by chance. On the contrary, the contract with the hospital was sought after insistently by Antonmaria, who came into contact with the hospital's functionaries when his father Noldo was admitted there. On Noldo's death Antonmaria respected his father's last wishes and left the hospital the Chiesimone farm near Reggello in Valdarno. Antonmaria personally took charge of the donation and thus met the directors of the hospital, who told him of their intention to rent out the Panzano farms close to his own in San Donato in Poggio. Thinking the offer an opportunity not to be missed, he asked Messer Bonino, the *spedalingo* (hospital administrator), if he could rent them himself, and was offered them for a period to last for the rest of his life. On 9 June 1479, a week before Lisa was born, Antonmaria went to the notary of Santa Maria Nuova and signed the deeds that donated Chiesimone to the hospital and gave him the concession on the Panzano farms.

However, Antonmaria's expectations were in part disappointed and on Christmas Eve the following year he regretted his decision and wrote a resolute, almost indignant letter: "I, Antonio Maria Gherardini, renounce the above-mentioned rent and from now on I no longer want it".[16] At the end of 1480 he sent his notice of cancellation but the contract was five-yearly and he was therefore obliged to wait until July 1484. When it was up, though, he had changed his mind once more and the

contract was only rescinded twenty years later in 1502. It seems that Antonmaria had rebuilt the farms after the destruction caused to them in 1478–79, making them once more capable of production, and so thought he would do better to keep them than give them up.

With the farms in Panzano, Antonmaria had six large properties in Chianti, all worked by sharecroppers, from which he produced crops of wheat, wine and oil that exceeded his requirements and which, with the earnings from the livestock, constituted the family's principal source of income. Like his father, Antonmaria did nothing personally for a living even though certain documents suggest he had dealings with a number of notaries and that he occasionally acted as an arbiter in disputes between private individuals. This was a rare occurrence, one that he may have practiced to top up his income as he hardly earned enough to give him the dignified life suited to a man often described as a *nobilis vir* in the notarial documents in which he was either a witness or arbiter.[17]

As Lisa grew, Antonmaria and Lucrezia had other children: in 1483 the longed-for son Giovangualberto, then Francesco, Ginevra, Noldo and two other daughters,[18] whom Lisa never forgot even when, more fortunate than them, she became a rich lady.

By 1494 the Gherardini family had moved out of the Corbinelli houses to Via de' Buonfanti (today Via dei Pepi) in the district of Santa Croce. They lived in a house on the Canto degli Orlandi on the corner of Via Ghibellina,[19] next to the house of Galeotto del Caccia, Lucrezia's father and Antonmaria's father-in-law.

The reasons for this move are unknown. Certainly Antonmaria was not prompt in paying his debts and this may have been why the Corbinellis did not renew the contract. At that point it is probable that his in-laws intervened and Galeotto—perhaps a better man than his name would suggest [*galeotto* is

Italian for "galley-slave" or "go-between", *translator's note*]—
did everything he could to persuade a neighbor to take them in,
at least on a temporary basis. The neighbor in question was a
rich Florentine merchant, Leonardo Busini, who, now single,
decided to accept the Gherardini family in his house. We do not
know if he did so for reasons of compassion or money as his de-
claration in the Catasto for 1495 says both that they were taken
in as they had no house but also for a high rent, and Busini
added immediately after with brutal frankness that "they are
there to my great inconvenience".[20]

In April 1494 Lisa and her family crossed the Arno to San-
ta Croce, next to the palazzo where her comfortably-off mater-
nal grandparents were living. The house was also close to that
of Ser Piero da Vinci, the father of Leonardo and one of the
most influential notaries in Florence. Not by accident Piero had
his office in the most strategic location in the city, facing the en-
trance to the Palagio del Podestà (the Bargello), which then was
the seat of the city's judicial offices.[21] It stands at the beginning
of Via Ghibellina and a few hundred meters from Via de' Buon-
fanti, where the Gherardinis lived. Who can guess how many
times Lisa, who was still a youngster, must have passed by Ser
Piero's office, perhaps also on the day of her wedding. And af-
ter too, holding her children by the hand on the way to her
grandparents' house.

Unlike his father Noldo, who had successfully built up a
fully respectable property portfolio, Antonmaria managed only
to maintain what he had inherited until 1495, after which his
only transactions were sales or transfers. At the start of that year
he gave away one of his loveliest properties in Chianti, San Sil-
vestro farm that lay between Castellina and San Donato in Pog-
gio. He ceded it to Francesco del Giocondo as a dowry for his
daughter Lisa as he had no ready money to give in its place.[22]

San Silvestro stands on the ridge of hills that separate the
Florentine and Sienese sides of Chianti. The place has mar-

velous views but is not easy to reach. The land is stony, steep and laborious to maintain and cultivate, and only vines and olive trees grow well there. The surrounding mountains and small valleys that stretch as far as the horizon are covered by thick woods, while lower down lie the irregularly shaped fields and farmhouses. The latter are stone cubes that stand apart and are difficult to reach. Nonetheless, many of the most distinguished families from Florence and Siena had their most beautiful properties in this often wild and bare area, of which they were proud.

In the mid-Cinquecento, even Michelangelo wanted to have a property in Chianti. In 1549 he told his nephew[23] to buy two farms—La Torre and Casavecchia—speedily and without worrying about the cost. The artist chose one of the loveliest corners of Chianti, though also one of the least convenient to reach, and became the owner of two large farmhouses and a plain medieval tower that stood imposingly at the entrance to the property. The land was wooded and planted with vineyards that produced—then as today—a fine red wine that Michelangelo proudly spoke of in his meetings with the pope in Rome. The two farms lay beside one another and very close to San Silvestro, which had been transferred to Francesco del Giocondo fifty years earlier as his wife's dowry.

Francesco del Giocondo's family

Francesco di Bartolomeo del Giocondo was born in Florence on 19 March 1465 in Via della Stufa,[1] in the house that his father Bartolomeo had bought and rebuilt a few years earlier, and which was to become the core of the family's future palazzo. Unlike the Gherardinis, who mostly lived on their unearned income, the Giocondos had always worked, first as simple craftsmen and later as manufacturers of and dealers in silk.

In the Catasto reports for 1427 the head of the family was Iacopo di Bartolomeo, a seventy-year-old artisan who had spent his entire life making wine barrels and become well-to-do. He had a shop near Via Vecchietti and lived with his wife, two sons and seven grandchildren in Via dell'Alloro in the district of Santa Maria Maggiore, not far from his workplace. His wife, Mona Tommasa, was fourteen years younger and together they had had Zanobi (thirty-eight years old) and Paolo (twenty-six). Zanobi was married to Mona Piera who had already had six children by the age of twenty-five; one of these was Bartolomeo, the future grandfather of Francesco del Giocondo. In 1427 the other son, Paolo, had not yet married but nevertheless had an eight-month-old daughter, Sandra, that his parents had happily accepted into the family. This bustling family was completed by a young servant of twenty-two named Caterina, who undoubtedly had plenty of work to do in keeping house.[2]

The Giocondos had begun as simple artisans performing one of the heavier manual tasks: in his workshop in Via Vecchietti Iacopo had passed his life modelling wooden lathes and iron rings to make barrels. The work was tiring but paid well and, as soon as he had saved enough, he bought himself properties in the city and farms in the countryside.

In Florence he bought two houses, the one where he worked in Via dell'Alloro and another in Champaccio, near Via Faenza, which he rented out. Outside the city he became the owner of a large farm near Florence on the plain of Badia a Settimo, with included a *casa da Signore* (the owners' house) and a *casa da lavoratore* (workers' accommodation). He bought the property in 1423 from Messer Rinaldo degli Albizzi,[3] one of the leading lights of the political scene in Florence and, as already mentioned, an unyielding opponent of Giovanni de' Medici in the power struggle of the early Quattrocento. Later Iacopo bought plots of land from Palla Strozzi in the same area and, just outside the walls of Prato, another fine farm around the hamlets of Santa Trinita, or so he claimed.[4]

Iacopo's two sons, Zanobi and Paolo, did not carry on their father's trade. Perhaps shrewder than him, they reckoned there were better gains to be made in dealing in high-quality fabrics and so joined the Silk Guild. In just a short period they managed to get a successful enterprise running and in July 1427 had an *entratura* (a sort of licence) and a positive balance of over five thousand florins (based on cash on hand, stock in the store, and bolts and cuts of cloth, silk, chenille, and taffeta).[5]

With the birth of the grandchildren, Iacopo's house in Via dell'Alloro became too small and his sons decided to move out. Fortunately for them, in November 1427 the Alberti family put their houses in the nearby Via dell'Amore up for sale. Without hesitating, Zanobi bought both in less than a week and turned them into one large home for himself and his brother.[6]

In 1458 Zanobi died leaving the company to his four sons: Antonio, Bartolomeo, Amadio and Giovangualberto. They were then not much over thirty and lived with their respective wives in the family house in Via dell'Amore. They were four young couples destined to create a family clan of more than twenty people. They had recently taken a new servant called Chiara, whose work must have been cut out trying to keep the women of the

house satisfied, and who was soon to fall pregnant, like her predecessor, Sofia.[7]

Next to the house in Via dell'Amore, the Giocondos had another, slightly smaller, which they rented out to a cloth weaver. And in the country, on the way to Badia a Settimo, they owned the farm with a *casa da Signore* that Iacopo had bought from Rinaldo degli Albizzi in 1423. The brothers therefore had the properties they had inherited from their father but had increased the size of the family business: turnover had grown and in 1450 they decided to enlarge the rooms of the workshop and to buy new stock. So by 1458 the four brothers had two licences and two shops in Por Santa Maria, in addition to which they rented another four years later. Here they produced and sold cloth, silk, crimson, and taffeta,[8] not just to the inhabitants of Florence, but also to countries on the other side of the Alps and even the Grand Turk.

At the end of the year Bartolomeo, the future father of Francesco, decided to set up on his own and, between October 1458 and January 1459, purchased three small houses (in his own words) in the quarter of San Lorenzo, two of which faced onto Borgo la Noce and the other on the parallel Via della Stufa. But after the contracts were signed, a long dispute entailed and Bartolomeo only became the owner of the houses in 1463.[9] He immediately started work on transforming them: he joined some rooms together, built a new reception room, and moved the main entrance to the Via della Stufa side, thus creating a fine house suited to his social standing. When he moved into the house he was about forty years old, was married to Mona Piera and had four children: Giocondo, Alessandra, Giuliano and Gherardesca. A fifth, Francesco, who was to become Mona Lisa's husband, was born on 19 March 1465.

In the years that followed, the Giocondos' silk business continued to grow but, like all the merchants of Florence, they also loved the tranquility and pleasures of the countryside, so

they bought several attractive properties outside the city when they were able to. After the costs of the shops and houses in Florence, and the expenses entailed in supporting the business and setting up their families, the Giocondos invested in land to protect themselves from the risks inherent in being traders but also to underline the social rank they had won themselves. In autumn 1463 Bartolomeo bought two farms on Montughi hill just outside Florence. He chose them not only for their position and the beauty of their situation, but also because they had a *casa da Signore* which he would visit during periods of relaxation, on hunting days and in the torrid months of summer.[10] The house gave a splendid view of the hills and city, in particular the two symbols of civic and religious life—Arnolfo di Cambio's tower and Brunelleschi's dome on the Duomo.

In 1480 the Giocondo brothers presented a joint declaration to the Catasto in which they detailed their assets and respective families. Since 1463 three of the families had lived together in Via dell'Amore while Bartolomeo's was housed in Via della Stufa. All had increased in size and now totaled more than twenty members. Bartolomeo was fifty-six and his wife Piera forty-three. They had eight children, three sons (of which Francesco, then fifteen, was the youngest) and five daughters, each with a dowry to ensure them a good marriage. Overall their property portfolio was the same as twenty years earlier: in the countryside they owned the farm at Badia a Settimo and the two at Montughi, plus one bought in Santo Stefano in Pane, while in the city they had the shops in Por Santa Maria where they made and sold silk.

In the following decade their properties remained unchanged, as did their respective shares in the company, which, after the growth achieved during Cosimo de' Medici's management, continued to prosper under Lorenzo, including through the entry of new partners. Unfortunately, all the company's administrative records have been lost with the exception of two

small registers that give a partial idea of the business and its dealings with other companies. For payments and other financial transactions, the Giocondo brothers made use above all of important bankers, the Medici in Rome and Luca da Panzano and Piero Mascalzoni in Florence. For example, in April 1490 they sold several bolts of Perpignan wool to a certain Gilar Bay, a Turk and servant to the Grand Turk, who was living in Rome. His payment for the goods was made to the Medici bank which then credited the account of the Giocondo company.[11]

The volume of business that passed through the bank of Lorenzo de' Medici and his partners in Rome was sizeable. On the death of the Magnificent (who left a mountain of debts) the Giocondos had 4000 florins in their account but were obliged to go to a lot of trouble to get them back from Lorenzo's son Piero. But their relations with the Medici were more complex and not limited to the collection of payments in the bank: from the few sources available we know that the Giocondos had dealings with the companies "Lorenzo di Piero de' Medici e chompagni lanaioli" and "Lorenzo di Piero de' Medici e chompagni setaioli". In other words, they were both customers and suppliers of the most important Medici companies in the wool and silk trade.[12]

The Giocondo brothers traded in high-quality fabrics but also finished products typical of Florence's artisans, such as the 50 tablecloths and 8 dozen matching napkins dispatched in June 1492 to a wholesaler in Rome.[13] Only a part of the company's output was for the local market, the rest was reserved for sales through their network of agents in the most important cities in Italy and abroad, particularly in France. On 26 October 1492, two weeks after Columbus had sighted land in the New World, the three brothers and two partners formed a new company "to deal in silk, both wholesale and retail, in Florence and Lyons and any other place they might wish". Without distinguishing between the sacred and the profane, they first invoked the "immortal and omnipotent God, His glorious Moth-

er, the Virgin Mary, and all the Saints so that their business affairs might enjoy a good start, better continuation and excellent conclusion", and then, one at a time, they signed the relative contract. The company's share capital was fixed at 8000 florins, three quarters of which they deposited themselves. The running of the company was divided between Florence and Lyons, obliging the administrators to work day and night ... for the good of the company and prohibiting them to indulge in any form of competition.[14]

After Florence, in Italy the brothers were particularly active in Rome where they had substantial dealings with the Curia and where in 1494 the sons of Giovangualberto Giocondo (Francesco's cousins) set up another company to "trade their wares and have dealings in Rome or wherever they might wish", thereby integrating their commercial activities with their financial dealings.[15]

The Giocondos were merchants but also held political posts: simply by belonging to the Guilds they often performed public duties. From the mid-Quattrocento to the early Cinquecento almost eighty members of the family were elected into the various bodies of the Republic or as Priors in the Seigniory (its executive body), or as members of the Dodici Buonuomini (the consultative body). They were particularly active in Florence's political life between 1480 and 1520, with more than forty representatives despite the political changes that took place at the end of the century. They were successful in remaining on good terms with both the Medici and their rivals. Shrewd and able in business, they showed the same skills in politics. They never left themselves open to attack, nor did they become involved in the often sterile struggle between the different factions, allowing them to enjoy a certain continuity in public affairs (a form of conduct that still seems to work today).

We do not know the year but between 1492 and 1494 Bartolomeo del Giocondo died. Following his father Zanobi, he

had represented the second generation of the family business and, with his three brothers Antonio, Amadio and Giovangualberto, he had taken the company to success. His place as head of the company was taken by his third son, Francesco, who, perhaps similar to his father in character and business sense, passed ahead of his two elder brothers Giocondo and Giuliano.

In 1495, after the Medici had been driven into exile and the subsequent tax reform had taken place, a property tax was introduced to Florence and new land-registry books were drawn up. The heirs of the four brothers had therefore to present a new declaration, one per person and not a joint declaration as they had done in the past. Thus they had to divide up the properties and decide on the ownership quotas of the company.

At the time Francesco was thirty, was married to his second wife and lived in the house on Via della Stufa. From his father Bartolomeo he had inherited a quarter of the two workshops where, since 1450, silk was produced, plus the third part of another store in Por Santa Maria purchased in 1482 and bordering on a property belonging to Piero di Lorenzo de' Medici. Close to the city, just above Porta San Gallo, he had the two Montughi farms, with a *casa da Signore* and workers' accommodation; and in San Michele in Ferrone in Mugello he had a small part of a farm bought by his uncle Antonio. And a few months before in Chianti he had become the owner of the large San Silvestro farm[16] between San Donato in Poggio and Castellina, which had been given to him by Antonmaria Gherardini as a dowry for his daughter Lisa, whom Francesco had taken as his second wife.

Lisa and Francesco's marriage

Until a few years ago it was thought that Francesco del Giocondo had married three times[1]: first, to Camilla Rucellai, second to a certain Tommasa Villani, and third, to Lisa Gherardini, who was to remain with him for the rest of his life. However, studies for this book show that he only married twice, and that there is no evidence to think otherwise: here is the sequence of events. In 1491 he married Camilla Rucellai and on 24 February 1493 his first child, Bartolomeo, was born. In July 1494 "Francesco del Giocondo's wife" died and was buried in Santa Maria Novella[2] in the family vault—this could not have been anyone else than Camilla. And in March 1495 Francesco married Lisa Gherardini.

Consequently he would have had only eight months available to marry, live with and prepare the funeral of the unfortunate Tommasa Villani. Furthermore, all the documents consulted (notarial deeds and his will) make not even the slightest reference to Tommasa or her dowry, as occurred for Camilla and Lisa.

Camilla was the daughter of Mariotto, one of the many businessmen in the rich Florentine Rucellai family. Bartolomeo, Francesco's father, knew the Rucellais well through his silk dealings (in 1457 Giovanni Rucellai still had an account open with the Giocondo brothers' company).[3]

The Rucellais were one of the richest and most influential families in the city and Giovanni di Paolo Rucellai was its most outstanding member, a wealthy man and a patron of artworks that were to become masterpieces of the Florentine Renaissance. It was he who commissioned Leon Battista Alberti to build his famous palazzo in Via della Vigna, and he invited the

same architect to renovate the nearby ancient church of San Pancrazio and to rebuild the facade of Santa Maria Novella.

Mariotto di Piero Rucellai belonged to another branch of the family but also lived in the main family house in Via della Vigna, on the corner of what was then Via degli Orafi (today Via dei Federighi). Also a rich merchant, he was married to Mona Pippa who had given him five sons and four daughters (one of whom was Camilla) over a period of twenty years.[4]

One of the last of the nine,[5] Camilla was born on 9 April 1475. When she reached adolescence her parents started to look for a possible husband for her among the most notable families of the time. On account of his social and financial standing, and for the role he played in the family company in Por Santa Maria, Francesco del Giocondo was considered a possibility. For their part the Giocondos, who were not of noble origin, had everything to gain by marrying into an aristocratic household and strengthening their ties to the city's most prestigious families.

After the customary preliminary meetings, the two families agreed the bride's dowry and exchanged rings; the marriage itself took place in 1491.[6] Camilla left the lovely palazzo in Via della Vigna and went to live in her husband's home in the less sophisticated Via della Stufa. At this time Francesco was twenty-six and Camilla sixteen. Unlike today, in those times marriages were contracted early and children born soon after. Indeed, the following year Camilla fell pregnant and gave birth to a son[7] on 24 February 1493. He was named Bartolomeo after his paternal grandfather, who had recently died.

The marriage seemed to have got off to a good start and so Francesco and Camilla hoped to have other children and build a large family—indubitably they could not have had any idea of the imminent and dramatic end to their marriage. We do not know why, whether for a pregnancy that ended badly or some illness, but Camilla died on 24 July 1494 at the age of just eighteen,[8] leaving her husband to look after the tiny Bartolomeo,

who had just turned one. The funeral was attended by members of the city's most important families but also many ordinary citizens—as was customary then—and the ceremony was held in the church of Santa Maria Novella where the Rucellais had their family chapel and where Camilla was buried.

After the mourning period was over and Francesco had assuaged his grief, in spring the following year he felt ready to marry again and create a family for the motherless Bartolomeo. We do not know how he came to know his second wife and, above all, her parents, as it was traditionally parents who organized marriages for their children. Perhaps they met in the shops in Por Santa Maria where the Giocondos retailed their goods, or through the circle of Florentine notaries that Francesco and Antonmaria frequented, primarily for business but also in the role of arbiters in civil disputes. Importantly, both families had been related to the Rucellais through marriage to two beautiful girls, though twenty years apart, and it cannot be excluded that Antonmaria had been present in 1491 at the sumptuous wedding of Francesco and Camilla and, three years later, at her funeral.

For whatever reason, on 5 March 1495 Antonmaria left his house early, went down Via de' Buonfanti where he lived and turned left into Via Ghibellina. Walking quickly and with a restless spirit, as though he had something he needed to get off his chest and mind, he headed to the house of a notary friend. The man was waiting for Antonmaria, welcomed him and read him the deed. Antonmaria signed without demur, though perhaps with a slight reluctance, because in so doing he renounced ownership of one of the longest standing properties of the Gherardini family, San Silvestro farm, which he left to his brash young son-in-law as a dowry for his daughter.[9] At the time Lisa was not yet sixteen but in the deed, which was written in Latin, she was referred to as "uxor dicti Francisci" [wife of the said Francesco]: so even at that date she was already married to Francesco del Giocondo.

The marriage contract usually ended with the mutual giving of consent and exchange of rings, and this was followed by the moving of the wife into her husband's home. Her staying the night there was considered an unequivocal sign of the consummation of the marriage. Generally, the parents of the bride handed over the agreed dowry before the wedding, over which the husband then had full control until his death, whereupon it could be returned to the ownership of the woman.[10]

The wedding was not simply an event that crowned the aspirations of the young couple, it was more often considered an institution that established the union of the bride and groom regardless of their personal feelings. Sometimes the couple did not even know one another: their marriage could be imposed by their parents or take place by proxy to create new alliances between families, or to ensure the conservation and transmission of estates.

In the case of Francesco and Lisa we can only conjecture on the reasons for their marriage. Lisa belonged to a well-to-do family that lived mainly on the yield of its farms in Chianti but did not have the economic or financial resources of the Giocondos. The conditions of the two families were substantially different: the Gherardinis had to cede a farm to give their daughter a dowry; Bartolomeo, Francesco's father, gave his four daughters a thousand florins each, ten times the value of Lisa's dowry.

Whereas it is easy to understand Antonmaria's motivation, who had everything to gain from the event, it is more difficult to comprehend Francesco's choice. Lisa's family had originally been distinguished but over the years it had lost its political and financial standing. Francesco was thirty, fourteen years older than Lisa, and it is probable that he was attracted by her youth and beauty (Vasari indeed described her as very beautiful). But it cannot be ruled out that, following Camilla's death, he chose her from a desire to provide his young Bartolomeo with a new mother.

After the wedding Lisa left her family home and moved into Francesco's house in Via della Stufa, a small, narrow street that leads out of Piazza San Lorenzo. It was a fairly common section of town and in a small building in the same street there were several noisy, brazen women of loose morals who usually animated the block. The house of Francesco and Lisa was large and was shared with Francesco's brothers Giocondo and Giuliano, the four sisters Gherardesca, Lisa, Margherita, and Marietta, the elderly mother Mona Piera, and Camilla's young son Bartolomeo.

Lisa's wedding to Francesco and her entry into the new family brought her security and well-being. She had married one of the well-known men of the city, a rich and astute merchant and man of public affairs (he had several times sat on the benches of the Seigniory). Her new status meant she took greater care of herself and her appearance, and this new image must have reflected her noble origins and the affluence of her new family.

She dressed well and on certain occasions even elegantly. Of course, with her husband in the silk business, she would have had fine clothes, and if Francesco was like the other members of his family and men of his rank, she would have been given jewelry. For example, over a period of ten years Bartolomeo (Francesco's cousin) spent a fortune on clothes and jewels for his wife and, at the birth of each of their children, he gave her a special present: a precious stone, a string of pearls or a gold bracelet.[11]

In those days, the woman was the pillar of the household and Lisa was no exception. She directed domestic life and ensured the continuity of customs on which family life was based. As a mother she felt deeply responsible for the growth, education and future of her children. And the title "Madonna" (Monna), which was given to her on account of her noble origins, evoked the typical female virtues, such as maternal love and ten-

der affection, but also a firmness of principles, moral rectitude and strength of character.

Lisa became pregnant shortly after the wedding and the following year, 1496, she gave birth to a son who was called Piero after his paternal grandfather,[12] and three years later she had a daughter, who was given the name Camilla.[13] This small but telling gesture probably reveals the humanity and natural goodness of Lisa, who was not yet twenty years old. Camilla was her own second name but also that of Francesco's first wife, and to accept it for her daughter may have signified respect for her husband's past life but also a continuity of affection for the young Bartolomeo, the son of Francesco's first wife.

Rich women had more children than their poorer counterparts and, as they did not breast-feed them, the intervals between one birth and another could be shorter. To be pregnant was an honour; usually a woman in childbirth was treated like a new bride and for a certain period was the most important person in the family. In 1493 one of Francesco's cousins, Zanobi, celebrated his wife and newborn son for more than one month, from late October to early December, spending more than six gold florins on sugared almonds and Trebbiano wine, which was a large sum in those days.[14] Generally children were not suckled by their mothers: the more well-off would have a wet-nurse in the home but otherwise the children would be given to peasant families. Their mother would then raise and educate them and it was common to look after them, especially the sons, even after they married.[15]

At the start of the sixteenth century Lisa fell pregnant three more times: after Piero and Camilla came Andrea in December 1502,[16] Giocondo in 1507[17] and, providentially, Marietta, who first helped her mother overcome a serious bereavement and later looked after her in her old age.[18] Lisa therefore had three sons and two daughters but raised six children as she looked after Bartolomeo with the same degree of love. No

episodes exist that suggest that any hostility existed between her and Bartolomeo, and following the death of her husband she several times appointed her stepson as her proxy[19] regarding her own succession.

We do not know anything about either Andrea or Giocondo, however, Bartolomeo and Piero went early to work in the shop, learning their father's trade and, on his death, taking his place as the fourth generation to run the family business.

From an early age the two daughters, Camilla and Marietta, were set for a life as nuns, even though the second was ordained after the early and tragic death of her sister.

Camilla took the habit in 1511 at the age of twelve. She also took the name of Suor Beatrice in the convent of San Domenico di Cafaggio, then in the open countryside between the church of San Marco and the city walls.[20] The convent contained other members of the Gherardini family: the elderly Suor Albiera (Antonmaria's sister), and two of Lisa's sisters, Suor Camilla and Suor Alessandra, to whom the new young nun was entrusted. However, Suor Camilla was not a good example to the girl as she was no model of chastity. Two years after Suor Beatrice's entry into the convent, Suor Camilla was involved in a scandalous episode in which she was accused of obscene acts by an interfering man fixated by propriety. Anonymous accusations (called *tamburazioni*) were very frequent in Florence and actually encouraged by the authorities who considered them an effective means of social control. The accusers would drop their denunciations in a special drum-shaped container [*translator's note*: the Italian word for drum is *tamburo*] inside the principal public buildings. The reports would then be taken to the competent magistrate for perusal.

According to one of these anonymous reports, on 20 April 1512 "four men with weapons and a ladder went to the convent of San Domenico and, after climbing the wall up to certain windows where two nuns were waiting for them ... remained there

three or four hours ... they touched the breasts of the said nuns and handled ... other things, for the sake of not detailing the obscenities committed".[21]

One of the scoundrels was no less than the brother of the cardinal of Pavia, accompanied by two friends, and the man who let them in was called Giusto, the young and dynamic manager of the convent's country properties. The two nuns waiting for them, wearing gold ruffs and adorned like brides, were Suor Camilla Gherardini (Lisa's younger sister) and Suor Costanza Corbinelli. Behind them were two others, Suor Diamante and Suor Diana, who were watching on with equal eagerness. Nor was it the first time that such a thing had happened: the city was filled with monks and nuns and not all of them were so saintly and chaste that they could resist the pleasures of the flesh, which were, after all, a gift from God. Proceedings were briefly held in which the nuns were acquitted and the four men sentenced.

Suor Beatrice died young. A few years after taking the habit she fell ill and passed away in January 1518 at the age of only eighteen, to the sorrow of her sister nuns and the consternation of her family. Lisa was by then a mature woman of forty or so and found comfort in prayer and those most dear to her. She visited churches and participated in religious ceremonies with devotion; perhaps her decision to send her second daughter to the convent was a consequence of the event. It was certainly a difficult decision to take and, given that the family was well-off financially and of good social standing—which would have allowed Marietta a fine dowry and to marry a rich Florentine merchant without problem—it is one that is more understandable on religious rather than human grounds.

Lisa visited the nearby convent of Sant'Orsola from the time of her marriage and supported it through generous offerings and the purchase of certain products: for example, on 29 August 1514 she bought a curious and mysterious distillate of

snail-water, the properties of which, whether therapeutic or cosmetic, we do not know.[22] After Camilla's death Lisa began to go to Sant'Orsola more often, taking part in the functions and activities held there. Within a few months of such visits, she had decided to allow her youngest daughter to stay with the nuns so that the girl would remain pure and chaste, progress her vocation and, above all, accustom herself to convent life before definitively taking her vows.

Sant'Orsola was one of the city's most highly regarded convents. It had extensive buildings and at the start of the Cinquecento was inhabited by more than sixty nuns, as well as the young girls waiting to take their vows. The convent was not just a place of prayer and the sisters alternated their meditation with different types of work. The day began early with morning prayers. After singing psalms the nuns left the chapel, their habits swaying, and started their daily activities. Many worked in the large loom room where they produced cloth for household linen; others embroidered sacred vestments or produced gold thread. Their products were sold to religious institutes in the city and gave Sant'Orsola a good income. One sister was in charge of all the different types of work and at the end of each month made a report to the Mother.

Getting a daughter into Sant'Orsola was not easy and, in addition, a costly business: it not only required the girl to come from a good background but also a large sum of money. This was established on an individual basis by the Mother depending on the reputation and wealth of the family. The family, on the other hand, was able to make unusual requests, as occurred for Cassandra Ricasoli, whose parents agreed to pay the 200 florins requested as well as brick up her cell and fulfil any other requirement; in exchange, the convent accepted that Cassandra would not have to obey the rules or carry out the religious duties.[23] In other words, a large sum of money could turn a convent into a comfortable and relaxing place to live.

On the other hand, for a well-to-do family a daughter as a nun was an undoubted saving. To marry her off well would require at least 500 florins, whereas to enter her in a convent cost a lot less. For example, Francesco del Giocondo set aside a sum of 1000 florins for his daughter Camilla in the event that she married and only 200 if she were to enter a convent.

Convinced she had made the right decision, one day Lisa took Marietta to the nearby convent. At the door they knocked, the nuns opened it and took the pair in to see the Mother. After a short interview, the inevitable exchange of compliments, and advice given to the young girl by Lisa, Marietta said goodbye to her mother and, somewhat apprehensive, disappeared down the long corridor wrapped in the vestments of two young sisters. Lisa returned home upset. She had only shortly before lost one daughter and knew that she had just set the second on a path of renunciation, at least on the human level, denying her the pleasures and affection of family life both as a wife and mother.

As specified in the meeting at the convent, the costs of meals were at the parents' expense. On 14 July 1519, on a muggy summer's day, Lisa left her home, still dressed in mourning, and went to Sant'Orsola. The Mother welcomed her with her usual respect, spoke to her of her daughter, her conduct and vocation, and hinted at the convent's many expenses. Lisa immediately understood, opened her purse and took out 18 gold florins. The nun opened her accouns book, entered the sum, the reason for the payment and the name of the person who had made it, and stated that it covered the period since January for the board of Marietta, the daughter of Mona Lisa del Giocondo. In large, pointed and slightly tremulous handwriting, which was natural for an elderly lady with poor vision, she referred to the noblewoman using the surname of her husband.[24]

Marietta took the veil on 20 October 1521 with the name Suor Ludovica and made her profession of faith during Mass on

Christmas Eve a year later.[25] Unlike her sister, Suor Ludovica lived a long life and died in 1579. Her conduct won her the esteem and trust of her convent sisters and after 1550 she was several times the representative of the institute; it was she who negotiated during various purchases of property by the convent.

Whereas Lisa's daily concerns were her home and children, each day Francesco went to the workshops in Por Santa Maria where, with his cousins, he followed the cloth production, dealt with customers and suppliers, checked the accounts and payments, and reflected on the legal questions that inevitably arose. Hints of such matters remain in the notarial archive in the many public documents—such as mandates, proxies, contracts and arbitrations—signed by him and other businessmen over the years.

One of these is the arbitrator's award made at the start of the Cinquecento for the division of the company's assets. After the death of the company's founders, the heirs—Francesco and some of his cousins—decided to define and separate their respective quotas, partly because Francesco was no angel and tended to overpower the others, as we shall see. In any case, the Giocondos were not inexperienced and, as was common, did not ask lawyers to act on their behalves but tried to find an agreement. To this end they asked two men to act as impartial arbiters, one of whom was Antonmaria Gherardini, Lisa's father and Francesco's father-in-law. The two men examined the company assets and decided to divide them in equal parts between the heirs.[26]

Another important deed was signed in March 1503. When Michelangelo was finishing his *David* and Leonardo was planning his *Battle of Anghiari*, Francesco was almost forty years old and, as a wise and responsible man, was already thinking about his legacy. He decided that a donation *inter vivos* between his children was the best thing to do. He reached an agreement with his trusted notary, fixed an appointment in the cloister of

the convent of San Gallo and, in the presence of several friars, donated "omnia et singula bona mobilia et immobilia" to his three sons Bartolomeo, Piero, and Andrea and set aside a sum of 1000 florins for his daughter Camilla.[27]

A month later, on 5 April 1503, he signed another deed at the same notary's office for the purchase of a house in Via della Stufa next to his own. Francesco was unquestionably an excellent businessman, he sold bolts of silk wholesale and retail and, when an opportunity arose, he knew how to grab it with both hands. He was intelligent, sharp and enterprising, with a business sense and lack of scruples that often bordered on illegality. Thus, when he found out that his artisan neighbor was drowning in debt, he proposed to pay off all the man's debts in return for the house, which was clearly the greater in value. The man accepted. Francesco kept the house for four years, probably renting it out, waited for the right buyer to come along and in the end got double the price he had paid.[28]

Francesco was known in the city to be bold, confident, and intolerant of rules and those who enforced them. When self-interest was at stake he would act regardless of the opinions of others and, in certain cases, he preferred to deal directly rather than accept the mediation of a judge. He was referred to as an argumentative type by the Otto di Guardia (the officers responsible for public order) when they had to deal with one of his nasty undertakings.

In May 1510 the Otto di Guardia had confiscated a large quantity of wheat in the farmland around Florence but Francesco, with disdain for this order, sent his agent to collect it, thus provoking the immediate reaction of the legitimate owner. Francesco was reported and in the charge he was described in harsh words, though an accuser would naturally do so. The terms were probably exaggerated but they give an idea of his character: he was painted as a man warped by sin and very confrontational, as this was how he behaved in all his un-

dertakings, to the extent that there were few offices in the city by which he had not been accused as a usurer. According to the person who drew up the charge, Francesco also acted in an ambiguous manner in the family company, resulting in several members of the family distancing themselves from him, considering him corrupt and unreliable.[29] This claim should also be taken with a pinch of salt because the writer was not impartial and had an interest in discrediting the merchant. In reality, Francesco had an important role in the family business and had succeeded in developing it both in Italy and abroad. He had visited Lyons several times to oversee the branch that the Giocondos had set up there.[30]

Consequently, Francesco was in contact with the most important commercial centers in Italy and Europe and was highly familiar with the money market, one from which he tried to profit. In one instance, in autumn 1503, the convent of the Santissima Annunziata—which he supplied with fabrics and holy vestments—asked him to convert a bill of exchange expressed in marks into cash. He acted upon the monks' wishes but made a profit on the operation.[31] Besides being a moneychanger, Francesco lent money but at a high rate of interest, particularly to members of the Church. On two occasions he was reported to the ecclesiastic court in Florence, made angry by the amount he charged, for usury: the first time in 1512 and a second in 1536 when he was an old man. Though he was nearing the end of his life, he had not lost his greed.[32]

He handled other people's money with confidence and was happy to manage that of his relatives too. For example, profiting from the good faith of his sister-in-law, he took over and used her dowry for his own ends after she had become a widow. He repeatedly financed the Gherardini family and made frequent loans to Lisa's father. In 1515 Francesco advanced his father-in-law almost 600 florins—roughly the value of a farm—but when he tried to recover the sum Antonmaria made it clear

that he was broke. To save her elderly father's honour, Ginevra saddled herself with much of the debt, thereby renouncing almost all her dowry, and the remaining sum was written off reluctantly by Francesco, who knew he would never get it back.[33]

More able than Antonmaria, Francesco also managed the assets his father-in-law had in Chianti: in 1502 he negotiated with the Spedale di Santa Maria Nuova for the return of the Panzano farms that Antonmaria had rented way back in 1479, the year of Lisa's birth, and succeeded in winning back for him all the expenses he had sustained for the improvements made to the fields and farmhouses.[34] Although Antonmaria expended lots of energy on his country properties and arbitrations in the city, his revenues did not increase whereas his family had grown in number. At the start of the Cinquecento, seven people lived with him: his wife Lucrezia, the three sons Francesco, Giovangualberto and Noldo, and three daughters, of whom two were recently born. As we know, the Gherardinis never had their own house in Florence and several times were obliged to move from one street to another, though lately they had remained within the district of Santa Croce. In the second half of the Quattrocento they had first lived in the district of San Giovanni, then in Via Maggio in Santo Spirito, and towards the end of the century they moved to Via de' Buonfanti in Santa Croce. At the start of the Cinquecento they changed house once again to live in Via Ghibellina in Canto alla Mela.[35] After that they moved once again to go to Corso dei Tintori[36] and finally to the Loggia degli Albizi[37] in an alley behind the house belonging to Ser Piero, the father of Leonardo da Vinci.

These continual changes upset Lisa, so, after the death of her father, she asked her husband to arrange for her siblings and their families to live in Via della Stufa in the house next door to their own. Francesco agreed, above all to please his wife though he knew it would not be a good arrangement. The Gherardinis happily moved into the Giocondo house and Lisa was particu-

larly glad to have them close because she could be personally in-
volved in the care of the children of her brother Giovangual-
berto, who had been left orphans on his death.[38]

We are unaware of when exactly Antonmaria died but in
1526 his children went to the notary (the same one used by the
Giocondos), signed the deed of succession and learned that
much of the property that had once belonged to the family was
no longer theirs. For various reasons Antonmaria had spent
what he had inherited from his father Noldo and in the early
Cinquecento all he had left were the farms at Cortine and
Selvoramole, a small house at San Donato and a mill on the riv-
er Pesa. The dowries for his daughters and a few sales to sup-
port his own payments and, perhaps, a tenor of life higher than
he could afford had by 1532 combined to deprive the Gherar-
dinis of more than half their country assets. In fact, seven years
later all they had left was a single farm (Cortine), the ancient
family residence.[39]

Whereas the Gherardini siblings lived in a rather scrimp-
ing manner and depended greatly on the generosity of their sis-
ter, no such problems affected the Giocondo household, where
abundance was more the norm. The family was numerous with
three generations living in the large house on Via della Stufa. In
1532, at the time the new tax system was introduced, Francesco
and Lisa were respectively sixty-seven and fifty-three years old.
They had already been grandparents for some time and with
them lived Bartolomeo and Piero with their respective wives
and children. The two daughters were of course no longer at
home since they had been sent off to the convent when young,
Camilla in 1511 and Marietta ten years later.

Bartolomeo and Piero started early to learn the silk busi-
ness but perhaps they were not as successful as their father.
Around 1510 Francesco came into conflict with his cousins and
was ousted from the company. He sold off his shares and with
the proceeds formed another with his sons. In the years that fol-

lowed he decided to sell the Montughi farms just above Porta San Gallo, to enlarge the properties in Chianti and, most important, to invest in the countryside around Pisa between the towns of Fucecchio, Pontedera and Ponsacco.[40] This provided the history of the family with a new twist, one that represented a radical change in their tradition.

Maybe Francesco had become aware of a flutter in the markets and had decided to put some of the commercial revenue into the property market, considering it safer and longer-lasting. This was indeed a very sensible thing to do, because the oldest families in Florence that have lasted until the present day have done so more because of the survival of their estates than their commercial businesses. In 1522 Francesco altered his habitual behavior and invested approximately 4000 florins in the purchase of several farms around Fucecchio and a large property from the Strozzi family at Gello, near Pontedera. The following year he bought other plots of land in the same area, towards Ponsacco. And then in 1528 he enlarged his farm in Chianti, the one that lay between San Donato in Poggio and Castellina.[41] In all he spent almost 5000 florins, a very large sum, which he probably collected by selling off his shares in several trading companies and the family workshops.

Some years later Francesco may have had the first presentiment of the end of his life because he went to the notary and made a will. He was by then close on seventy; he had lived through all the crucial moments of the city's history in the second half of the Quattrocento and now probably felt the weight of the years.

Born in 1465, the year after the death of Cosimo il Vecchio, he had grown up during the age of Lorenzo il Magnifico, had listened to the sermons of Savonarola, and had seen Michelangelo at work on the statue of *David* and Leonardo on the cartoons of *The Battle of Anghiari*. He had been present at the birth and decline of the republican experiment at the start

of the sixteenth century, had lived through the siege of Florence in 1530 and now, with the advent of the Principate and the suppression of the ancient institutions, felt the city was on the threshold of a new political phase, perhaps even a new epoch.

Francesco made his will on 29 January 1537, a year before his death, in the presence of his trusted notary, a colleague and seven witnesses, all simple citizens, of whom one was a builder and another a greengrocer.[42]

After invoking the mercy of God and all the heavenly court of Paradise, and wishing for agreement and fraternal love between his heirs, he asked to be buried in the Martyrs' chapel in the devout church of the Santissima Annunziata where the Giocondo family had its tomb,[43] and to keep the place lit up with an oil lamp *in perpetuum*. He also asked that prayers and masses should be held for the state of his soul, left a small bequest to the Opera del Duomo and a sum of money, two sets of bedlinen and six nun's shirts to his daughter Suor Ludovica. He then thought of Lisa, "eius dilecte uxor" [his beloved wife], for whom he had only words of esteem and affection. Perhaps they were dictated by the circumstances but it is true that during his life Lisa had always been loyal and a virtuous woman both as wife and mother. If Francesco had felt differently and not loved and admired her, he could have skipped over certain passages or watered down the warmth of his regard for her. At the end he showed himself to be very caring and even worried for Lisa's health and old age, and included an entire provision in the will for her welfare in the future.

Following the opening formula, Francesco gave instructions for Lisa's dowry to be returned to her, the lovely farm of San Silvestro that lay between Castellina and San Donato in Chianti. Then, referring to his love for her ("mutuum amorem et dilectionem dicti testatoris erga dictam Lisam eius dilectam uxorem") and the nobility of her spirit ("et attento qualiter se gessit prefata domina Lisa erga dictum testatorem ingenue et

tanquam mulier ingenua"), he left her all the clothes and jewels he had given her at the happiest moments of their life together.[44] He charged his daughter Suor Ludovica to care for her mother and take all those steps necessary to look after her health; he also obliged Ludovica's brothers to respect whatever measures the nun would need to take. He arranged the dowries for his two granddaughters Cassandra and Camilla, the daughters respectively of Bartolomeo and Piero, and exhorted his family to avoid all forms of disagreement and to work at finding union, peace and fraternal love. Finally, he appointed his two sons Bartolomeo and Piero as his sole heirs.

Francesco died at the start of 1538[45] and a year later his children and Lisa faced up to the complex question of the inheritance. There had always been good relations between them and on this occasion too they behaved very sensibly. They appointed Filippo Buonsignori as arbiter, who drew up an appraisal of all the assets and then divided them equally between the two brothers. Bartolomeo was given three-fifths of the farms at Fucecchio and Pontedera, plus the baker's shop in Via della Stufa, making a total value of 4500 gold florins. To Piero went the other two-fifths of the properties at Fucecchio, the farm in Chianti and the large house in Florence, with all the wardrobes, chests and benches and other wooden furniture for a value of 4100 florins.[46] Furthermore, the two brothers divided between them the bonds in the Monte Comune (public debt), and the assets and liabilities of the family businesses, including those of the two companies in Antwerp and Lyons. Finally, Bartolomeo agreed to move out of the large house in Via della Stufa within four months as this had been left entirely to his brother, who continued to live there with his family and Lisa.[47]

When the agreement was signed on 17 June 1539, Mona Lisa was exactly sixty and knew that she would spend the rest of her life with her son Piero, lacking for nothing. With gen-

erosity and a maternal spirit she also forsook her dowry and assigned it to Suor Ludovica, her only remaining daughter.

This was the last existing reference made to Lisa and despite investigations in different directions we do not know how long she continued to live. This very probably confirms that she was present in Florence at the time Vasari attributed to her the face of *La Gioconda*. Maybe Lisa, old and ill, spent the last years of her life in the convent of Sant'Orsola assisted by her daughter Suor Ludovica. This would not have been unusual because it was customary for the convent to accommodate single women, widows and the sick, giving them board and lodging in exchange for two gold florins a month.[48]

Francesco's two sons, Bartolomeo and Piero, inherited a huge legacy but did not manage to conserve it, nor to increase it. They were neither as astute nor as enterprising as their father but, to be fair to them, they were operating in a completely different historical context, one characterized by economic decline and the progressive distancing of Florence from the political scene in Europe.

With the death of Francesco the family company lost its proud leader. It was split between the sons and began a slow and inexorable decline. Bartolomeo and Piero took over management of the company, each responsible for his own part, but towards the middle of the Cinquecento they found themselves in great difficulty: they had lost their best customers, their order book was suffering and to pay their creditors they were forced to sell some properties.

Bartolomeo died on 2 December 1561. He was buried in the family chapel in the Santissima Annunziata and left to his son Guasparri a sizeable inheritance but also a company in crisis. The wretched Guasparri attempted everything to bring the company round, even bringing in a new partner, but this measure just complicated the problems. At the start of November 1564, worn out and disconsolate, he gave up and declared himself bankrupt.

Fifteen days after the judge in the bankruptcy court opened the proceedings, the questioning began. Unfortunate even in his name, Guasparri was examined several times in the court of Stinche prison, an enormous, dismal block that stood between Piazza Santa Croce and Via Ghibellina. Rather intimidated, he stated what he had been doing, confirmed the list of creditors—which contained the best-known craftsmen, merchants and bankers in Florence—and at the end of the interrogation was obliged to remain in the city until he received further instructions.

When Guasparri took over the company it was already in deep trouble, but he was also partly responsible for pushing it over the edge. Indifferent to its financial difficulties, and with a good dose of irresponsibility, Guasparri, who was a gambler, lost a huge sum of money one evening in just two hours playing the card game primero with some friends in Via del Moro. He searched through his pockets but, not having the required sum, he wrote out an IOU though this was never paid.[49] When the player to whom the money was owed found out about the bankruptcy, he went to the court and asked to be included among the personal creditors.

When the judge had confirmed the company's list of assets and liabilities, he ordered Guasparri's goods to be confiscated and put up for auction, and had the relative announcements posted in the streets. However, at the end of April the following year, an agreement was reached: Guasparri was to pay off two-thirds of the creditors in exchange for which he took back possession of his goods and regained his freedom, but the name of the Giocondo family was on everyone's lips for six months.

During the period that Guasparri was attempting to save his company, important works were taking place in the Palazzo Vecchio and nearby site of the Uffizi, designed and directed by Giorgio Vasari. Despite his burdensome commitments and con-

tinuous presence on the site, the artist found time to write (one of his passions) a second edition of his *Lives of the Artists*, the original of which had been published twenty or so years previous. It was a long and meticulous task that came to an end in 1568 with the printing of the new edition in Florence. Vasari revised the original text, added various chapters and corrected numerous inaccuracie. But, as we shall see, did not alter the page dedicated to Mona Lisa.

Mona Lisa and her identity

In the pages that recount the life of Leonardo da Vinci, Giorgio Vasari described the portrait of Mona Lisa with enthusiastic and admiring words, considering it even then a masterpiece.[1] But he never saw the work in person and this fact induced him to include some inaccuracies and, perhaps, to embroider the knowledge he had. For example, he refers to the lady's eyebrows, but she has none in the painting (unless they have been painted over or removed since), and his claim that musicians and jesters were employed to keep the model amused seems very improbable; however, Vasari's unique account has its own appeal and deserves to be included entire.

"For Francesco del Giocondo Leonardo undertook the portrait of Mona Lisa, his wife, and left it incomplete after working at it for four years. This work is now in the possession of Francis, King of France, at Fontainebleau. This head is an extraordinary example of how art can imitate Nature, because here we have all the details painted with great subtlety. The eyes possess that moist lustre which is constantly seen in life, and about them are those livid reds and hair which cannot be rendered without the utmost delicacy. The lids could not be more natural, for the way in which the hairs issue from the skin, here thick and there scanty, and following the pores of the skin. The nose possesses the fine delicate reddish apertures seen in life. The opening of the mouth, with its red ends, and the scarlet cheeks seem not color but living flesh. To look closely at her throat you might imagine that the pulse was beating. Indeed, we may say that this was painted in a manner to cause the boldest artists to despair. Mona Lisa was very beautiful, and while Leonardo was drawing her portrait he engaged people to play and sing, and jesters to keep her merry, and remove that melancholy which painting usually gives to portraits. This figure of Leonar-

do's has such a pleasant smile that it seemed rather divine than human, and was considered marvelous, an exact copy of Nature."[2]

La Gioconda represented a turning point in Renaissance portraiture. The innovative position of the figure and her monumental appearance had not been seen before, in fact, it was frequent to paint the figure half-length and in profile, in imitation of ancient coins. In Leonardo's painting, La Gioconda sits majestic on a parapet with a primordial and imaginary landscape behind her. The woman is not in a static position but seems to have been portrayed in the act of turning: the rotation of her bust seems to start from her hips, which face left, and is completed in her face, which looks in another direction straight into the eyes of the observer.[3]

The other great novelty in the painting is the landscape. In earlier portraits the landscape related to and was consistent with the life of the model, but Leonardo's portrait overturns that relationship radically. Here the landscape is built vertically and is seen from above looking down, in a "bird's eye" view.[4] The line of the horizon does not continue evenly but is broken in two, with the line on the left decidedly lower than that on the right. This almost imperceptible asymmetry gives the painting a sense of dynamism that matches the motion of the figure. She is perceived on different planes to the landscape: higher on the left and lower on the right, resulting in the entire image being endowed with a sense of movement.

The imposing nature of the figure is given by the pyramidal composition: at the base are the arms and hands, pushed forward into the foreground and balancing the whole; at the top, the wide neckline and face, with an expression that is striking for its vitality. Despite the lady's solemnity, she is not rigid or statuesque, she seems to have been caught at a particular instant, like a frame in a film, able to change her expression continually. The broad use of sfumato and the lack of definition in

certain important details and their outlines ensure that it is the observer who "defines" them, filling them in with his or her own sensibility. Clearly the artist achieved these results not just through his great ability in the use of color but also, and most importantly, by means of his brilliant intuition regarding the distribution of light and shade on the figure of the woman and, in particular, on her face.

It is not only a matter of fashion that *La Gioconda* has become the most famous painting in the world. Undoubtedly it is one of the most important works by Leonardo and in the history of art in general. The extraordinary quality of the painting, the originality of the placement of the figure, the power of her gaze, and the complexity of the psychological aspects that are evoked all arouse enormous interest, and this, in turn, is nourished by the mystery that shrouds the identity of the model. In other words, we do not know with certainty who La Gioconda was, nor who commissioned the painting or whether it originated with Leonardo himself. Perhaps, inspired by a woman of his own time, he ended by portraying her in a manner that was more symbolic than real.

If we were to discover her real identity, it would add nothing to the beauty of the painting. Knowing if it really were Lisa Gherardini or another woman would not alter the exceptional aesthetic value of the painting; nonetheless, streams of words have been written on the subject and there has been a series of studies attempting to explain who the woman may have been.

Until a century ago, *La Gioconda* was for everyone a portrait of Mona Lisa Gherardini but the theft of the painting in 1911 triggered a clamorous press campaign that initially centered on who was responsible, but ended by also discussing the identity of the lady. On 21 August 1911 a young Italian decorator, Vincenzo Peruggia, with extreme ease removed the painting from its frame, wrapped it up in his jacket and carried it out of the Louvre.[5] Everyone was left amazed and alarmed, especially

the French, who never thought such a thing possible. An inquest was opened and the museum was actually closed for a week.

For almost two years the international press looked into the matter and, just as interest was beginning to wane, a banal incident in a cheap hotel in Via Panzani in Florence brought *La Gioconda* back into the limelight. With the intention of restoring the painting to Italy—for an adequate payment, of course—Peruggia contacted the officials at the Uffizi Gallery and in November 1913 went to stay in Florence at the hotel in Via Panzani (today called the Hotel Gioconda). The experts at the Uffizi asked to be able to examine the painting in their laboratories but as the young man was leaving the hotel with the painting under one arm, the suspicious owner of the hotel blocked his way thinking his guest was trying to steal hotel property.

The young man went back to his room, called a photographer and was obliged to go to the Uffizi with a copy of the painting. When the museum officials saw it, they immediately understood what they were dealing with. They invited the decorator to return to his hotel and tipped off the police. Peruggia was arrested and the painting handed over to the staff of the Uffizi where it was shown for several days, attracting a large number of visitors. *La Gioconda* remained in Florence until 19 December 1913, when it was transferred to Rome and handed over to the French authorities.

Until this episode the identity of the lady in the painting had for centuries been believed to be that of Lisa Gherardini. Its title—*La Gioconda*—is derived from that of her husband, Francesco del Giocondo, and though it seems to have been used for the first time only shortly after the death of Leonardo, it entered into common use in the early seventeenth century.

For reasons of inheritance, in 1525 an inventory of the goods of one of Leonardo's pupils was drawn up; his name was Gian Giacomo Caprotti but was known commonly as Salaì. The list contained several paintings, some clearly masterpieces by

the maestro. At the top there is reference to a Leda, a Saint Anne and, further down, a portrait of a woman set back, referred to as "la Honda" but immediately corrected to "la Ioconda".[6] We cannot know if this was the original or a copy but it is a fact that a few years after Leonardo's death, one of his pupils had a painting with this name.

Though only occasionally, the name Gioconda was used during the second half of the Cinquecento but it became more regular with the advent of the Seicento. For example, in 1625 Cassiano dal Pozzo, secretary to cardinal Barberini and an art lover,[7] saw the painting at Fontainebleau and referred to it using that name. He was astounded by the painting and the woman portrayed appeared to him so beautiful and alive that he said, gripped by emotion, that she lacked nothing except speech.

Twenty or so years later, in 1642, it was the turn of father Pierre Dan, the historian at the Château de Fontainebleau, who confirmed what Cassiano had written and described the work as the portrait of a virtuous Italian woman (and not a courtesan as some believed) called Mona Lisa, vulgarly known as La Gioconda, who was married to a Gentleman from Ferrara [in fact from Florence, *author's note*] named Francesco Giocondo. Being a close friend of Leonardo, Francesco had given permission for the artist to paint a portrait of his wife. Therefore, according also to father Dan the lady in the painting was Mona Lisa, who was undoubtedly a virtuous woman, but he added a new and significant detail: that Leonardo and Francesco del Giocondo had been friends, a fact that has till now been ignored and which may instead have played an important role in the commissioning of the painting. The probable friendship between Leonardo and the husband of Mona Lisa may also be borne out by other facts that are yet to be examined.

At the center of the debate that opened at the start of the twentieth century[8] lay not so much the name as the identity of

La Gioconda. Dozens of hypotheses have been put forward, some of them highly fanciful: there are those who recognize in her the portrait of various Italian noblewomen, some a pregnant woman,[9] others the mother of the artist, and it has even been suggested that it is a portrait of the female side of Leonardo's own nature. But there are also some who believe the painting to be the synthesis of all his artistic and scientific activity and consider it his painted autobiography.

Simplifying the issue, there are essentially two underlying but contradictory accounts that have fed the debate for some time and which divide the historians into two camps. In chronological order, the former (and lesser known) is by Antonio de Beatis who in 1517 visited Leonardo on a trip to France and probably saw the painting. The later account, which is much better known, is the one written by Giorgio Vasari who, using information provided by others, explained the origins of the painting in his *Lives of the Artists*.

Antonio de Beatis was the secretary to a Neapolitan cardinal who loved traveling. The two went to France where they happened to find Leonardo in the Château de Cloux, where he lived. The artist showed them his paintings, one of which he said was a portrait of a woman from Florence, and stated, according to de Beatis, that it had been commissioned from him by Giuliano de' Medici during the artist's stay in Rome between 1513 and 1516.[10] If the client was really Giuliano de' Medici, the brother of pope Leo X and resident in Rome for a long time, it is improbable that he asked Leonardo to portray Lisa Gherardini, a lady from Florence, and therefore the figure in the picture is another woman. But, as Donald Sassoon observes, none of the women that Giuliano would have had portrayed would have been from Florence and thus none of them could have been the Florentine woman to whom Antonio de Beatis referred. In short, de Beatis's claims seem rather fragile and unconvincing.

The other account on the identity of La Gioconda is Vasari's, in the chapter he dedicated to Leonardo da Vinci in his *Lives of the Artists*. The first edition of the book was published in 1550 and the expanded and corrected second edition in 1568.

Giorgio Vasari was born in the Tuscan town of Arezzo in 1511 and stayed in Florence on and off between 1524 and 1536. On several occasions he went to Rome to follow the works produced by Michelangelo, of whom he was a great admirer, but it was the Florentine artist's advice to Vasari to give up painting and to concentrate exclusively on architecture. After 1554 Vasari became the court architect of the Medici and received the most important commissions of the period: he directed the heightening of the Salone dei Cinquecento and in 1560 began construction of the Uffizi, his greatest work and a masterpiece of sixteenth-century Florentine architecture.

As is known, Leonardo was born in Vinci close to Florence on 15 April 1452 to a family of notaries. It was his grandfather Antonio who recorded the baptism certificate of the boy[11] born from a union between Ser Piero and a certain Caterina, the household servant who then took off to marry a young man from the area. At the time, behavior of this kind was not unusual and caused no scandal. The baby was welcomed into Ser Piero's house with joy and the baptism—attended by witnesses, relations and friends—was a joyful event for the whole hamlet. The father was almost always out for work, moving from village to village on horseback to sign contracts, make agreements and arrange compromises between obstinate and argumentative parties, while the young Leonardo was taking his first steps and trotting round the streets of Vinci.

Leonardo spent his infancy with his grandparents and uncle Francesco but grew up in a calm family atmosphere without suffering much the absence of a mother. When the moment was right, his father did his part: he understood and supported his son's vocation and, as soon as Leonardo was an adolescent, set

him off into the world of the arts by apprenticing him to one of the best teachers in Florence.

With time Ser Piero extended his clientele in the city and began to go more often to Florence, eventually becoming one of the notaries to the Medici. Between 1456 and 1462 he visited the family palazzo in Via Larga several times to deal with the family's legal affairs, in particular Cosimo il Vecchio, whom he knew well. Together with some colleagues, in 1461 he rented a *bottega* for notarial use opposite the Palazzo del Podestà at the start of Via Ghibellina. He lived in the district of Santa Maria Sopraporta, close to the Ponte Vecchio.[12] He was married to Albiera Aldobrandi, by whom he had a daughter named Antonia in honor of his own father, but on 15 June 1464 Albiera died in childbirth and Ser Piero remained a widower for the first time. However, his spirits were not down for long and the next year he married Francesca Lanfredini, but this union too ended quickly with Francesca's early death. Ser Piero also overcame this second bereavement and married a third time in 1475, to Margherita Giulli, who lived to give him four sons and a daughter.[13] At the time the notary's family lived in a house owned by the Merchants' Guild on the corner with Piazza San Firenze. The building was later bought by the Gondi family, enlarged and turned into their family palazzo. In 1479 Ser Piero finally managed to sell off the house that had been left to him thirty years earlier by a client, allowing him to leave his rented house and move into a new one at the start of Via Ghibellina.[14] This faced the Bargello and lay over the *bottega* where he practiced his profession.

By this time he was getting on and thought he had reached a degree of serenity but fate had other plans and even his third wife, Margherita, died prematurely, leaving her husband with a house full of children, many of them young. Piero was discouraged but once again rolled up his sleeves and tackled the situation. He took a servant into the house, fell in love once more

and in 1485 married Lucrezia Cortigiani, a woman of just twenty-five. Ser Piero must have been a man of great resources (and Leonardo resembled him more than the other children): married for a fourth time, he had a further six children by his new wife—five boys and a girl.

When sitting down to a meal, Ser Piero was faced by more than a family, it seemed like a school class. Next to his young wife sat eleven children of all ages, from the eldest, a young man, to the youngest, who was still to be spoon-fed. It is understandable why, when Leonardo returned to Florence, he preferred not to stay in the house: his father's wife was actually younger than himself and liked to boss everyone around. He didn't really know any of his half-brothers and sisters, particularly those by the last wife, and they were so small and noisy that he got no peace.

In spite of the many children he had had by different women and long after Leonardo was born, Ser Piero never forgot his illegitimate son. On the contrary, like every good father he did what he could to help, making use of his contacts in the principal institutions in Florence. For instance, it seems that it was Ser Piero who got Leonardo the commission from the convent of San Donato at Scopeto, of which he was the notary, for the famous *Adoration of the Magi*. Likewise, his good offices permitted Leonardo to receive lodgings at the guest quarters of the Santissima Annunziata, and it was very probably Ser Piero who presented Francesco del Giocondo to Leonardo when the artist returned from Milan. And of course it was Ser Piero who set Leonardo off on his artistic career by sending him to one of the best and most efficient workshops of the period, the one belonging to Andrea del Verrocchio, which was also close to home in a side-street of Via Ghibellina.

Leonardo remained several years at Verrocchio's school. He learned the tricks of the trade and developed and refined his own extraordinary artistic skills. Andrea del Verrocchio was a

versatile artist. A painter and sculptor, he also studied nature and directed a workshop in which all the arts were taught: drawing, painting, metal casting, sculpture in marble and stone, and the design of large works in bronze.

For Leonardo it was ideal to find himself in an environment so congenial to his interests. Verrocchio's curiosity and passion for experimentation, and the many activities that took place in the workshop encouraged the young artist to study nature and the human body systematically.

He was not interested in books, knew little Latin and even less Greek (says Vasari) and every time he found himself confronted by a problem he preferred to solve it himself empirically. He had no scientific ambitions and believed that the way to understand the world—in order to represent it artistically—was to study nature. In short, nature was the principal source of his artistic inspiration and understanding it was the real aim of his studies.

Leonardo was a genius in the arts and sciences and intuited several profound human truths, as his writings seem to suggest: for instance, only love generates human life and it is love that differentiates human life from animal life, as for the latter all that is important is the biological element. However, he went further: he believed that the creative power of the mind and our attachment to life are developed in the womb and are the fruit of the sincere love of the parents at the moment of conception.[15] This was an extraordinary claim for the time and shows, yet again, the depth of Leonardo's thought in every field of knowledge.

In 1482 he left Florence for the court of Ludovico Sforza in Milan, where he found an even more stimulating environment. To a greater extent even than in the learned and intellectual atmosphere of Florence, it was in Milan that he deepened his research into painting and sculpture and the sciences. As an artist he matured ideas and developed a fundamental conception that characterized all his work: objects do not exist in

emptiness, he claimed, but are surrounded by the atmosphere and thus cannot be represented in any other way; bodies move in space but space is not empty, it is made up of air and light.

With this conviction, he conceived painting in a new manner, defining volumes and forms through light, color and the reflections of the bodies and atmosphere. He turned his back on the rigid perspective of the early Renaissance and gave depth to his paintings using an original technique that is referred to as aerial or atmospheric perspective. This represents the space in which his subjects or objects are immersed in the air and light: they are shown clearly defined in the foreground but less so in the distance. He gave his figures "moto e fiato", according to Vasari, in other words, movement and life. The gestures of his subjects are natural and sure, their poses graceful and well-balanced. The compositions of his paintings are solid and dignified, almost always monumental. As he wrote himself, a good painter must know how to paint two fundamental things, man and his mind: the first is easy but the second difficult because it has to be realized through the subject's gestures and movements of the limbs.

Leonardo left Milan at the end of 1499 after the defeat of the Duke by the French. He stayed for a while in Venice and Mantua, then, in spring 1500, moved to Florence where he stayed as a guest of the friars of the Santissima Annunziata. They asked him to paint the altarpiece of the high altar and he prepared a sketch, but the commission was never completed.[16]

He set off on his travels again in 1501 and spent time at the court of Cesare Borgia as a military engineer in early 1503. He then returned once more to Florence and stayed as a guest of the Martelli family in Via Larga, close to the Duomo. He stayed in the city until 1506, then went back to Milan and from there to Rome in 1513. He left Italy for ever in 1516 following an offer by the French king, François I, of protection and excellent accommodation in the Château de Cloux, close to Amboise, where he died three years later.

Leonardo's stay in Florence is confirmed by repeated withdrawals he made from his current account at the hospital of Santa Maria Nuova between 1503 and 1506, where he had deposited his pay from the Duke of Milan.[17] During those years he was given important commissions but he also suffered profound and bitter disappointments: in 1504 the death of his father, who had been a solid and constant reference point in his life, and the year after, the disastrous failure of his fresco of *The Battle of Anghiari*.

When his father died Leonardo was little more than fifty and he was more upset than his notes suggest. He jotted down the event in just a few words and with a certain detachment that may in fact reveal a deeper emotion.[18] Ser Piero was very well-known in the city; he had been a notary for approximately sixty years, had known the most illustrious families and for decades had been the legal representative for many monasteries. Shortly before dying he had the umpteenth meeting with the friars of the Santissima Annunziata, whom he had defended for almost forty years, for one of their usual disputes.

Ser Piero died on 9 July at about the age of eighty. He left twelve children—ten sons and two daughters—who later quarreled over the inheritance of the many properties he had bought up during his indefatigable career. The funeral was held the next day in the nearby church of Badia Fiorentina, where he was also buried. The presbytery was filled with representatives of the religious orders Ser Piero had himself represented. Behind the coffin, sitting among the clouds of incense, were the family, authorities and citizens. In the front benches sat his wife Lucrezia and her many children, while sitting a little apart was the firstborn, Leonardo, who was silent and absorbed. Others present may have included Francesco del Giocondo who, as we shall see, knew Ser Piero and had been his client for some time.

According to Vasari, Leonardo painted the portrait of Mona Lisa during the four years he remained in Florence, but

they were four years of suffering: this meant that to Leonardo, who had a mania for perfection, it remained imperfect. He was not prepared to hand it over to the client and in fact kept it in his possession for the rest of his life.[19] Vasari was well informed about Leonardo's movements and his stay in Florence, as well as several episodes that took place at the Santissima Annunziata at the start of the century. These can be taken as a clear sign of the seriousness and reliability of his claims, which do not seem to be the fruit of superficial or vague enquiries.[20]

The Santissima Annunziata was a large complex consisting in a church and an adjacent monastery that then housed seventy friars and novices, plus a large number of laymen with various responsibilities. Until a short while ago, it was one of the most visited churches in Florence as its theme was very popular with the religious feelings of the Florentines. An instance of their devotion to the Annunciation is that until 1750 the first day of the New Year for the inhabitants of Florence fell on 25 March, the feast day of the Santissima Annunziata. The city became festive and people congregated in the square of that name—an architectural and urbanistic jewel—where the popular traditional fair was held.

The church was visited by a continuous flow of worshippers who, in exchange for presumed blessings, left the friars with donations in the forms of money, precious objects, gold, and silver. Consequently the monastery had a small treasury which it kept in a wooden, iron-bound chest known as the "jewel-box with the three keys"; the name was derived from the number of its locks and the number of people required to open it. In the early Cinquecento, friar Mariano—said by Vasari to have been the one who was at the candle counter—must have been to some extent the factotum of the monastery, and was one of the three who, with the sacristan and prior, had access to the chest. At some time, though, he must have abused his role as on

his death his brother monks were amazed to find a large number of silver objects in his cell.

At the start of the century Ser Piero, Francesco and Leonardo were frequent visitors to the Santissima Annunziata, and father Stefano, the prior, knew them all well: Ser Piero because he helped to resolve the monastery's incessant disputes, Francesco del Giocondo because he lent the monastery money and came back insistently for his repayments, and finally Leonardo because the prior had asked the artist to paint the altarpiece and, to help him in this task, had given him accommodation in the monastery.

At the time Francesco was thirty-five. He had several children and was the head of a profitable but risk-taking trading company. In early December 1502 Lisa gave birth to another child, Andrea, an event that prompted Francesco to protect his children more securely, so in March 1503 he decided to register all his assets in their names. It may have been that he also wished to pay tribute to his wife, and to do so invited one of the most famous artists of the day to paint her portrait, payment for which he would not have had any problem in finding.[21]

This is the most common hypothesis advanced but also the most convincing: Francesco had a lovely family, a young wife, a birth to celebrate, an aristocratic house and the work of a great artist to display. It all makes sense but there is nothing to corroborate it: no trace has been found of any commission made by Francesco to Leonardo despite long searches through the books of the notaries Francesco used. However, even if no proof exists, it is very probable that the two knew one another and that there was no lack of occasions for them to meet.

When Leonardo returned to Florence in 1500, he stayed for a long time in the Annunziata, which Francesco visited as a businessman and worshipper. In fact, the Giocondo family tomb (where he too was to be buried) lay in the Servite church there. During this period Francesco was often in the offices of Santa

Maria Nuova to resolve one of his father-in-law's concerns and Leonardo used to visit the same place to make anatomical studies of the dead and to draw money from his account there. And when Leonardo moved into the Martellis' house in Via Larga, he was living just a couple of steps from Via della Stufa and close to the route that Francesco took every day to visit the workshops in Por Santa Maria.

In 1503 the Republic commissioned Leonardo to paint *The Battle of Anghiari* on the walls of the Sala del Consiglio (then known as the Salone dei Cinquecento), though this was later destroyed due to the artist choosing the wrong fresco technique. If we are to believe Vasari, the cartoons for the fresco were produced in the pope's room in Santa Maria Novella[22] before being transferred to the walls in the Palazzo Vecchio. While work was being done on this commission, Leonardo and Francesco were moving around in the same area of the city, between San Lorenzo, Santa Maria Novella and Por Santa Maria: the artist to prepare and produce the enormous fresco, the merchant to open up his shop and sell his wares. Furthermore, Francesco was well known in the city,[23] as he had held various public positions and frequented the offices of the city government. Nor can it be ruled out that he had been present at the award of the two important public commissions to Michelangelo and Leonardo for the Palazzo della Signoria.

These are all hypotheses, but there is another supporting factor that might have aided in bringing the two figures together. Francesco knew Ser Piero well, having turned to him several years earlier regarding a dispute with the monastery of the Santissima Annunziata on the subject of a bill of exchange contested by the friars.

Ser Piero was an established and highly regarded notary in Florence. He had a select and influential clientele, for example, the rich Jewish traders, the most important monasteries and convents, and the best families in the city. In short, he was a member of the two most important circles in Florence at the

time, the trading and ecclesiastical societies. In 1497 the Servites at the Annunziata and the Giocondo brothers turned to Ser Piero to resolve a dispute. He was the trusted notary of the religious brothers and a friend of the family, and indeed the compromise reached was drawn up in the Giocondo workshops in Por Santa Maria.[24] But this was not the only, nor the first document drawn up for the family. Between 1484 and 1487 Ser Piero intervened several times over a legal question between Zanobi di Domenico del Giocondo (Francesco's cousin) and the Capitolo dell'Annunziata, of which Zanobi was the proxy.[25] The notary had for some years been in contact with the Giocondo brothers and it can be supposed that he visited the family's shop with his wife to purchase fabrics and other articles, if only because he lived in nearby Via Ghibellina.

Therefore Francesco knew Leonardo's father at least by 1497, at the time when the artist was still in Milan working on the fresco of *The Last Supper*, and maybe through Ser Piero he was introduced also to the son when he returned to Florence. Of course, their acquaintance is not a proof that the portrait was commissioned by Francesco,[26] but it may have lain at the origin of the painting and on this subject Vasari's affirmations merit further consideration.

When Vasari gave up on painting to concentrate on architecture, Francesco had been dead for some years but his family members were all still alive and could provide precise information on the subject. Moreover, between 1524 and 1536, before Francesco's death, Vasari had stayed several times in Florence, and it is possible that Francesco himself told Vasari about the execution of the painting. Francesco died in early June 1538 and his funeral was held in the church of the Annunziata where the family had recently built their family tomb. As Francesco was known in the monastery, all the monks paid homage to the coffin and participated in the ceremony in their high-backed wooden seats. The mass was sung and officiated by several cel-

ebrants, then, as was customary, the family offered candles for the altar and the worshippers.[27] At the end of the service, Francesco's coffin was buried in the family tomb among wafts of incense and to the sound of chants.

Some years later, in the years following 1540, Vasari began to gather the documents and accounts that would form the basis of his *Lives of the Artists*. At the time Lisa would have been little more than sixty and there was no-one better than her to tell the story of the painting of the portrait. Of course her children and siblings were still living in Via della Stufa and Francesco's numerous relations were still alive, and Lisa still had sisters and a daughter in two famous Florentine convents. If Lisa had really posed for Leonardo, they too would have known about it and perhaps talked of it with one of their ecclesiastical sisters; and, as is known, convents have always been famous for spreading gossip.

On Francesco's side, there would have been many possible witnesses to the painting of the portrait; over the years the family had grown new branches and at the start of the sixteenth century had a large number of members.

If Francesco commissioned the portrait from Leonardo, it is highly improbable that he did not talk about it with his siblings, uncles and aunts and cousins, whom he saw every day in Por Santa Maria. And if, as is to be expected, the shops were centers of gossip, it can be supposed that the fact became known outside of the family circle. In conclusion, we can suppose that many people came to know about it and that what Vasari wrote before 1550 was probably founded on their reports.

Vasari was well acquainted with the Giocondo family. He certainly knew one of Francesco's cousins, also called Leonardo, who was of the same age and a business partner, and Leonardo's son Piero, from whom he could have learned about the portrait of Mona Lisa.[28] Furthermore, he knew that

Francesco had built the family tomb in one of the most renowned chapels in the Santissima Annunziata, the semicircular one behind the high altar. He had seen it several times, knew the furnishings and also the history of the painting that was supposed to have been realized for it. He knew that Francesco had commissioned such a painting from the Florentine artist Domenico Puligo, but it turned out so beautiful that, altruist as he was, he preferred to keep it in his own home.[29] After his death, Bartolomeo had another painting hung in the chapel, though one much more mediocre. In this case too, Vasari knew the truth because he learned the details from a monk.[30]

The monastery of the Annunziata probably played a crucial role in the whole business, first, as a place where Ser Piero, Francesco and Leonardo could meet, and second as an inexhaustible source of information for Vasari, both for his *Lives of the Artists* and the description of the portrait of Mona Lisa. The monastery had three close ties to the cultural and artistic circles of the city. It housed the Accademia delle Arti e del Disegno, at one time called the Compagnia di San Luca, of which all the artists resident in Florence were members. When the Accademia organized the funeral of Michelangelo, whose body arrived in Florence from Rome on 12 March 1564, one of the responsible counsellors was Giorgio Vasari, who continued to hold the post in the years to come.[31] This explains why he was so well informed on the lives of the Florentine artists and, even more so, on the works they had produced for the friars of the Annunziata at the start of the sixteenth century when Leonardo was their guest. Vasari had several reasons to visit the Annunziata and the friars knew him as a man, painter, and writer. They had read the first edition of the *Lives* and were well acquainted also with the second, to the extent that they contested Vasari's version of a sum paid to a painter who had worked for them. The Annunziata was a place of prayer but also of

memory, and if Leonardo painted the portrait of the wife of Francesco del Giocondo—with whom the friars had had contact for many years, first as a merchant-banker, then as the head of the family's chapel—the friars must have known it and told the meticulous writer.

In addition, the monks remained in contact with Francesco's family after his death for very particular reasons, above all, the funerals of his sons, especially those of Bartolomeo in 1561 and Piero in 1569, both of whom were buried in the family chapel built by their father. Another reason was that in his will Francesco had arranged for an oil lamp to be kept alight in the chapel *in perpetuum* with the obligation that his heirs should provide the oil. Moreover, after the failure of his business, Guasparri (Francesco's unfortunate grandson) became a clerk in the Annunziata, thus being constantly present in the monastery and maintaining the long link that the Giocondos had had with the monks since the time of Francesco, his grandfather.

And there is more. At the start of the Cinquecento all the great artists were to be found in Florence. Leonardo was working on Mona Lisa's portrait and the cartoon of *The Battle of Anghiari*; Michelangelo had recently completed his *David* and was preparing the sketches for *The Battle of Cascina*, the two frescoes meant to celebrate the ancient glories of the city and decorate the salon in the Palazzo Vecchio; Raphael visited the city to see the works by the two great artists, of which everyone was talking; Sandro Botticelli was still alive, though introverted and prey to mystical crises; Filippino Lippi was dying but younger painters like Perugino and Andrea del Sarto were making their reputations; and there were the Della Robbia brothers and Baccio d'Agnolo, the carver, sculptor, and architect, whose workshop was filled each evening with artists, Raphael included, according to Vasari.

Raphael moved to Florence prevalently to follow Leonardo and Michelangelo, and when he painted the portrait of Mad-

dalena Strozzi, he took the portrait of Mona Lisa as his model. This is clear from the many similarities between the two works. If Raphael saw the portrait of Mona Lisa, he would have discussed it with the other artists at Baccio d'Agnolo's workshop and even Michelangelo would have come to know of it, thus becoming a potential contributor to the subject in his interviews with Giorgio Vasari in Rome.

Vasari's *Lives of the Artists* met with success and a large number of copies were published and sold within a few years. The book circulated in the city and many would have read the pages on Leonardo and the passage dedicated to Mona Lisa. If this section of the book had not corresponded to the truth, there would have been many relations and friends who could have contradicted it, and Vasari would have been obliged to alter his text for the second edition, as he did for certain errors. For example, in 1550 he wrote that Ser Piero had been Leonardo's uncle but revised the text to make him Leonardo's father in the 1568 edition.

After 1554 Vasari lived stably in Florence in a house in Borgo Santa Croce, a small street that runs diagonally from the church. Despite being busy on the design and construction of the Uffizi between the Palazzo Vecchio and the river Arno, he never stopped thinking about his *Lives*, adding new parts and revising existing ones for the second edition that came out eighteen years after the first. He gave it a slightly different title (*The Lives of the Most Eminent Painters, Sculptors and Architects*). He expanded the text and corrected inaccuracies, having had the opportunity to understand things much better and to revise many others, as he stated in the introduction.[32]

Therefore, Vasari reread and revised all of the first edition, but the section on Mona Lisa remained unaltered in the 1568 publication. During the period that separated the two editions, Vasari had the chance to check the account he had given in the first, particularly as there were many of Francesco's relations

alive, including three of his sons: Bartolomeo, his eldest son by Camilla Rucellai, who died in 1561; Piero, his eldest son by Lisa, who died in January 1569; and Suor Ludovica, his youngest daughter and a person with responsibilities in the convent of Sant'Orsola, who died in 1579.[33]

In the mid-sixteenth century, the Giocondo family was still present in the city and several of its members held important public posts: Zanobi del Giocondo was the Camarlingo in the Silk Guild,[34] and Messer Antonio presided with Duke Cosimo over the management of the Santissima Annunziata.[35] And then there was the unpropitious event that brought the family unwanted attention. During the years Vasari was preparing his second edition, the bankruptcy of Guasparri del Giocondo, which had affected so many families, was a central subject of conversation in Florence. Comparisons were inevitably made with the past generations of the family, and the destitution of the present contrasted with its past glories when it was run by the cantankerous Francesco, happily married to Mona Lisa.

Given the large number of people aware of the reality of the situation both inside and outside the family, it seems improbable that Vasari did not tell the truth in 1550 and again in 1568 when he had become an established figure. And what gain could there possibly have been to give a false account of one of Leonardo's most famous paintings, which was even then considered a masterpiece?

When Vasari wrote the famous sentence, "For Francesco del Giocondo Leonardo undertook the portrait of Mona Lisa, his wife", he wrote it with full awareness and not as an off-hand comment. In the end, his entire account was invalidated by one inaccuracy, a detail—her eyebrows—that he described but which are not in the painting. Vasari never saw the original and it seemed normal to him that they should have been included, as Leonardo's technical mastery would have meant they were not a problem to paint.

In conclusion, the personal and family events of Lisa and Francesco, their probable friendship with Leonardo, the repeated claims made by Vasari and the many people aware of the true situation make it difficult to believe that La Gioconda was not in fact Lisa Gherardini, at least in a first phase of the painting. As mentioned above, Leonardo began the painting in Florence between 1503 and 1506 but did not complete it. He became very attached to it and took it with him on his moves to Milan, Rome and then to the French court at Amboise, where he died in 1519.

We do not know if the portrait was commissioned by Lisa's husband, as Vasari leads us to suppose, or whether it was Lisa's personality that inspired the artist to undertake, unwittingly, what was to be a unique work of portraiture for that time. Very probably Leonardo knew Francesco del Giocondo and he may have been struck by some aspect of his young wife: her beauty, as Vasari stated in his *Lives*, or the nobility of her spirit, as her husband wrote in his will.

In any case, with *La Gioconda* Leonardo became involved almost maniacally in a fully original project and challenge: one that required him to go beyond the faithful reproduction of a Florentine noblewoman and to transfigure her features and expression so as to create an idealized image.[36] Through the use of successive layers of paint, made at a distance of years, the artist modified the original painting until it took on its current appearance. As he took it up from time to time, he rethought it and completed the figure in the foreground and the landscape behind, eventually producing a work that is prevalently symbolic: it is no longer the portrait of a woman but an ambitious and brilliant representation of mankind through the complexity of our physical and psychological elements. Indeed, the noble and dignified pose of the unadorned figure, her lively, intelligent glance, the gentleness of her features and the delicacy of her flesh make her seem almost a secular member of royalty.

The body of the lady in the painting almost seems to have a soul, one might say, and from this and the drapery around her transpires something profound, something that suggests one of man's higher faculties—self-knowledge.[37] Looking at her closely, La Gioconda seems aware of herself, able to think and interact; the expression on her face is not just the result of the movements of her muscles but also of deep emotions and drives. This is what makes this painting great: the fully successful attempt to represent together body and mind, and also—in my opinion—the mystery and absolute that is in each of us. In the end, this little panel made of poplar wood, so skilfully elaborated and painted, becomes the synthesis and emblem of all the complex and extraordinary activity of the great artist, Leonardo da Vinci.

Appendix

*This is the testament of Francesco di Bartolomeo
del Giocondo, drawn up in Florence on 29 January
1537, a year before his death. The original was in
Latin and written in an irregular, untidy and muddle
handwriting, as was often the case in notarial
documents in the Cinquecento. Furthermore, in several
parts the ink has either faded or is missing completely,
making comprehension of the text very difficult.
The transcriptions are first in English, then Latin.
The Latin has been revised by Paolo Collini,
a teacher of Greek and Latin.*

Francesco di Bartolomeo del Giocondo's will, 29 January 1537

The 29th day of the month of June in the year of our Lord 1537. Deed drawn up in Florence in the district of San Pier Maggiore, in the house of the notary undermentioned, in the presence of the witnesses below and dictated by the testator himself.

> Ser Ludovico di Ser Giuliano da Vicorati, notary
> of Florence
> Clemente di Iacopo di Antonio builder
> Bastiano di Iacopo Fattori greengrocer
> Niccolò d'Antonio of the district of San Pier Maggiore
> Piero di Niccolò Bonini of the district of San Michele
> Visdomini
> Iacopo di Francesco of the district of San Miniato
> Stefano di Taddeo Stefani of the district of
> San Pier Maggiore

As nothing is more certain than death and nothing more uncertain than its hour, the prudent and noble Francesco di Bartolomeo di Zanobi del Giocondo, a citizen of Florence, wishes and intends to leave his worldly goods to the members of his family, for the benefit of his soul and to avoid disputes and arguments that may arise between his children and heirs, so that they may remain in agreement and continue to enjoy fraternal love.

First, knowing that the soul is more precious than the body, the said testator trusts in the mercy of the Lord and commends his soul to omnipotent God, to his sweet Mother and all the heavenly Court of Paradise and asks that his body be buried in the Church of the Annunziata in Florence, in the

Martyrs' Chapel, which he recently had painted and in the tomb of his predecessors. With regard to the expenses of the funeral, his heirs will decide on the most appropriate way for their payment.

He leaves to the Santa Maria del Fiore organization of Florence, to the new Sacristy in that same place and to the construction of the city walls three florins.

He gives instructions that his children and heirs have his body buried and taken to the above-mentioned tomb at the Ave Maria in the evening or the Ave Maria in the morning, depending on when death comes.

He gives instructions that, once death has come and for the benefit of his soul, his children will have Gregorian masses and other customary masses celebrated in the place where he is buried, making candlewax and edible offerings that they consider most appropriate.

As a legacy he leaves Suor Ludovica, his beloved daughter, a nun in the convent of Sant'Orsola, a florin and a half of gold each month as long as she shall live, to be paid the day before the death of said testator. Payment shall be made into the hands of Suor Ludovica, for which she shall make out a receipt, and the convent may not claim anything of it. In her prayers Suor Ludovica shall remember her father, and shall pray that the omnipotent God and his most glorious Mother shall intercede to save his soul. And in the event that his heirs shall miss payment on two consecutive occasions, they shall be obliged to give their sister five large gold florins each month.

He gives instructions that, immediately after his death, his heirs shall provide Suor Ludovica with monastic habits,

two sets of linen and wool sheets, six nun's shirts and ten ells of fine Rheims linen to make her wimples and all that she shall need.

He leaves to Mona Lisa, his beloved wife and daughter of Antonmaria di Noldo Gherardini her dowry.

He also leaves to his wife Lisa, from affection and mutual love, all the clothes and garments that she shall be using or wearing, whether of wool or linen, and all the jewels and other things that she shall be using or wearing when he dies.

Given the affection and love of the testator towards Mona Lisa, his beloved wife; in consideration of the fact that Lisa has always acted with a noble spirit and as a faithful wife; wishing that she shall have all that she needs; having faith in the goodness, affection, benevolence, discretion, and judgment of Suor Ludovica; wishing to leave a person in his place who shall see to the needs of Mona Lisa, the testator charges Suor Ludovica to act in his place, and thus his children and heirs are held to give and lend Lisa all that shall be said, called for, decided or declared by Suor Ludovica, in any manner or form without objection or exception.

If Suor Ludovica is prevented from doing the above-mentioned things, or in the event that she dies before her mother Lisa, her place will be taken by my son Bartolomeo [Francesco's eldest child, *author's note*], with the same powers of his sister Suor Ludovica.

As the testator has at this moment two sons, Bartolomeo and Pietro, and as Pietro has a daughter named Camilla and that Bartolomeo has another named Cassandra and that the daughter of Pietro has a dowry in the bank of the Commune of Florence

of 1440 florins, the testator leaves Bartolomeo's daughter 200 trees of her choice, whether she becomes a nun or marries, and 600 trees to her future husband as her dowry; in the event that she dies before marrying or becoming a nun, these trees shall be given to Bartolomeo's other daughter. If Bartolomeo has no other daughters, these trees shall pass to the testator's heirs.

He leaves to Caterina, currently his servant, everything that shall be decided and stated by Suor Ludovica, as much as for her servitude as for her dowry or as a gift, seeing that the testator has conferred this power on Suor Ludovica.

He instructs and charges his heirs to deliver, within a month of his death, a barrel of oil to the friars of the Santissima Annunziata in Florence to keep alight the lamp on the altar and in the chapel where he shall be buried, and they shall be held to do so every year; in the event that they cease to give the oil for two consecutive years, they shall be obliged to pay the friars 50 large gold florins, who shall in return keep the lamp alight *in perpetuum*, in honor of God and for the benefit of his soul.

As the testator wishes to eliminate every cause of disagreement between his children and to maintain the peace in his family, he expressly orders that none of his heirs may in any way open lawsuits between themselves and furthermore that all creditors and debtors in his account books or those of Andrea and his brothers shall be satisfied.

He leaves instructions that each of his sons, their wives and children may have and keep the clothes and things that they are wearing or using at the moment of his death, without requiring that these shall be counted among his worldly goods to be shared.

He leaves instructions that, within six months of his death, his sons and heirs shall make an inventory of all his goods so as to have a clear and precise list.

Considering that more has been received by the household from the dowry of Bartolomeo's wife than from the dowry of Pietro's wife, and as the testator wishes to act fairly, Bartolomeo may take from the mass of the inheritance 500 florins to make up the difference when the division of the goods is made.

For all his remaining worldly goods, he appoints Bartolomeo and Pietro to share them in equal parts as his sole heirs.

(5r) In Dei nomine amen. Anno Domini nostri Iesu Christi ab eius salutifera incarnatione 1536, indictione decima, die vero 29 Ianuarii. Actum Florentie in populo Sancti Petri Maioris in domi mei notari infrascripti, cum talibus infrascriptis testibus, infrascripti testatoris ore proprio ad infrascripto omnia et singula vocata, habita et rogata, videlicet:

ser Ludovico ser Iuliani de Vicorato notario imperiali florentino

Clemente Iacobi Antonii muratore
Bastiano Iacobi de Factoris hortolano
Nicolò Antonii de (...) populi sancti Petri Maioris

Petro Niccolai de Boninis populi sancti Michaellis Vicedominorum
Iacobo Francisci de Frianis populi sancti Miniatis
Stephano Taddei Stephani populi sancti Petri Maioris
Quoniam nil est certius morte et nil incertius eius hora animoque prudentis pertinet ut mortis semper cogitetur ... semper mori.
Hinc est qualiter prudens et nobilis Franciscus olim Bartolomei Zenobii de Iocundis civis florentinus volens et intendens circa eius familiares ut ... integra et sua bona integra ... facta dispositione consilit providere et de bonis suis disponere pro salute anime ipsius et etiam pro

tollendis litibus que oriri possent inter infrascriptos eius filios et ut essent et permaneant in ea concordia et dilectione fraterna qua decet omni infrascripto modo quo melius potuit hoc presens nuncupatim testator quod sine scriptis dicitur facere, procuravit et fecit in hunc quem sequitur modum et formam etc.

In primis quidem attento quod anima est pretiosior corpore, idcirco prefatus testator confisus Domini misericordia animam suam omnipotenti Deo eiusque clementissime matri totique celesti curie paradisi humiliter ac de nomine racommendavit corporis ... sui sepulturam elegit et esse voluit in illa devotissima ecclesia Annuntiate civitatis Florentie in cappella Martinum novissime per dictum testatorem pingi facta, Et in sepulcro eius predecessorum, cum illa funeris impensa prout videbitur infrascriptis eius heredibus.

(5v) Item iure legati reliquit opere sancte Marie Floris de Florentia et sacrestie nove eiusdem et costructioni murarum civitatis predicte in totum f. 3. Item voluit et disposuit prefatus testator quod infrascripti eius filii et heredes sepeliri faciant cadavere dicti testatoris morte eius secuta et efferri ad sepulcrum predictum ut vulgo dicitur "all'Ave Maria della sera" o vero "all'Ave Maria da mactina" secundum tempus quo mors contigerit.

Item voluit, iussit et disposuit quod secuta morte ipsius testatoris dicti et infrascripti eius filii teneantur pro salute anime ipsius testatoris celebrari facere missas sancti Gregorii cum offitio mortuorum et cum aliis missis consuetis in loco ubi sepelietur ut supra cum illa cera et cum piatanza ... prout eisdem filiis videbitur.

Item iure legati reliquit sorori Ludovice filie dilecte dicti testatoris ad presens moniali in monasterio sancte Ursule cum sancto ... singulis mensibus donec ipsa naturaliter vixerit, florenum unum cum dimidio alterius floreni auri largi in ante a die mortis dicti testatoris, volens et precipiens quod solutiones fieri debeat in manibus propris dicte sororis Ludovice et ab ea fidem receptionis semper recipiant et istius proprie fuit et monasterio nil queratur ad hoc ut in orationibus suis recordiatur dicti eius patris et omnipotente Deum et eius gloriosissimam matrem oret et deprecetur pro salute anime dicti testatoris et ad

(6r) hoc etiam ut sibi in indigetis suis providere possit. Cum hoc quod casu quo infrascripti heredes dicti testatoris cessarent in duabus pagis continuis cunsequentibus tunc et eo casu teneantur singulis mensibus eidem sorori Ludovice solvere et dare f. quinque similes.

Item voluit et disposuit prefatus testator quod immediate secuta eius morte infrascripti eius heredes teneantur dare dicte sorori Ludovice omnes pannos monasticos pro ... et prestare ei similiter dua paia di lenzuola d'accia et di lana et sei camice da monache et 10 braccia di rensa per farsi sogholi et per far quello che gli fussi di bisogno.

Item reliquit domine Lise eius dilecte uxori et filie olim Antonmarie Noldi de Gherardinis dotes suas ... ut dixit confessatas.

Item eidem domine Lise propter mutuum amorem et dilectionem reliquit et legavit ut vulgo dicitur tucte le sua veste et tucti e' sua panni che sono o alhora saranno a suo uso o a suo dosso, così lanii come linii et di qualunche altra sorte et tucte le gioie che l'havessi con tucte l'altre cose mobile che sono o che saranno a suo uso o a suo dosso tempore mortis dicti testatoris cuiuscunque generis sint.

(6v) Item propter amorem et dilectionem dicti testatoris erga dictam dominam Lisam eius dilectam uxorem et attento qualiter se gessit prefata domina Lisa erga dictum testatorem ingenue et tanquam mulier ingenua; quapropter intendens prefatus testator providere ut post mortem dicti Francisci prefata domina Lisa pari modo aliquo habeat et ut subveniatur ei in eo quo opus esset, Et confisus propterea prefatus testator summopere ei bonitate, dilectione, benivolentia, discretione et iuditio dicte sororis Ludovice et desiderans loco sui personam aliquam relinquere que possit dicte domine Lise in eius indigetis subvenire ei providere, Idcirco prefatus testator circa predicte in omnibus et per omnia reliquit prefatam sororem Ludovicam loco sui ipsius testatoris, adeo quod dicti et infrascripti eius filii et heredes teneantur et debeant eidem domine Lise dare et prestare totum illud et quicquid dictum in proprium arbitratum aut declaratum fuerit per dictam sororem Ludovicam quodcunque sit cum omne eius simplex verbum et voluntatem et totiens quo eas opus fuerit et eo modo et forma ... arbitrata fuerit. in hoc dictos eius

et infrascriptos heredes qualiter dare et prestare dicte domine Lise totum illud quod per dictam sororem Ludovicam factum, dictum, arbitratum aut quolibet declaratum fuerit absque aliqua obiectione vel exenptione. Et casu quo prefata soror Ludovica modo aliquo non posset infrascriptis vacare aut facere ea que supra dicte sunt vel casu quo predecederet dicte domine Lise, tunc et eo casu prefatus testator reliquit Bartolomeum eius filium circa predicta loco dicte sororis Ludovice et cum eadem autoritate.

(7r) Item considerans prefatus testator de presenti habere duos filios, Bartolomeum et Petreum, et considerans qualiter prefatus Petreus habet unam filiam nomine Camillam et qualiter prefatus Bartolomeus habet unam aliam filiam nomine Cassandram, et considerans qualiter prefata filia dicti Petru habuit et habet constitutam dotem super Monte Comunis Florentie florenorum 1440 in circa et intendens prefatus testator equalitatem inter dictos eius filios et eorum filias servare. Idcirco prefatus testator reliquit dicte filie dicti Bartolomei 200 arbores dicti testatoris ad eius electionem si monacharentur et si viro tradentur similiter arbores 200 ubicunque sint et uniuscuicunque futuro viro et marito arbores 600 intuitu in dotis et propterea dotis, et casu quo decedet antequam nuberet vel monacharetur, tunc dicta arbores sint alterius filie femine dicti Bartolomei, si quem aliam suscipiet impostam, in et casu quo nulle alie existerent ex dicto Bartolomeo filie femine, dicte arbores sint heredum dicti testatoris.

Item reliquit prefatus testator Caterine vel … dicta romandiola ad presens famule dicti testatoris totum illud et quicquid arbitratum et iam declaratum fuit per dictam sororem Ludovicam tam pro servitu quam pro dote seu pro lemosina eorum, nunc prefatus testator dedit et tribuit talem auctoritatem dicte sororis Ludovice.

Item iussit, voluit et mandavit prefatus testator infrascriptos eius heredes qualiter secuta morte dicti testatoris inter mensem dent et tribuant fratribus Annuntiate civitatis Florentie unum barilem olii pro tenenda accensa una lampada ad altare et cappella dicti testatoris et sic successive postea teneantur singulis annis in perpetuum, et casu quo cessarent dare oleum predictum per duos annos continuos fratribus predictis, tunc et eo casu teneantur dare fratribus predictis fl. quinquaginta auri largos pro dicto effectu et dicti fratres postea teneantur et teneant dic-

110

tam lampadam accensam in perpetuum in honorem Domini et pro salute anime ipsius testatoris (…).

(7v) Item desiderans prefatus testator tollere omnem causam discordie que nasci posset inter dictos eius filios et ad hoc ut in unione et pace et dilectione fraterna consistant talibus suprascriptis et infrascriptis gravavit, voluit et disposuit et expresse precepit prefatus testator infrascriptis eius heredibus qualiter nil unus alteri vel ab altero modo aliquo eorum causa quacunque quomodocunque excogitanda possit parere et riconverso fine sint aut reperiantur creditores aut debitores in partitarum libris aut Andree … olim alterius fratris sive in partibus rerum testatoris sadeisdare imposuit et imponit per … adeo quod eius alterum modo aliquo molestare non possit.

Item voluit et disposuit prefatus testator che ciascheduno de' decti sua figlioli et loro donne et figlioli si habbino et sì si tenghino e' sua panni et le altre cose che ciaschuno ha a suo o per suo uso o dosso absque aliqua alia divisione de predictis facienda.

Item voluit et disposuit prefatus testator qualiter dicti eius filii et heredes infrascripti teneantur infra sex mensibus a die mortis dicti testatoris conficere inventarium de omnibus bonis dicti testatoris ad hoc ut de eis lumen et nota appareat.

Item considerans prefatus testator qualiter de dote uxoris dicti Bartolomei plus venit in domum dicti testatoris quam de dote uxoris dicti Petri et … animo prefatus testator omnia predicta et considerans eque … erga utrunque providere et attento quod de quam pluribus … providit prefatus testator dictis eius nuribus et … omnia consideran… voluit et disposuit qualiter prefatus Bartolomei habeat et precipiat et precipere possit de massa hereditatis fl. 500 de sigillo si quando venerint ad divisionem bonorum et reliqua sibi dividere.

(8r) In omnibus autem aliis suis bonis presentibus et futuris sibi heredes unuversales instituit, fecit et esse voluit prefatos Bartolomeum et Petrum eius filios legiptimos, naturales equis portionibus.

Leonardo da Vinci, *Portrait
of Mona Lisa del Giocondo
(Mona Lisa)*, 1503–1504, 1510–1515
Musée du Louvre, Paris

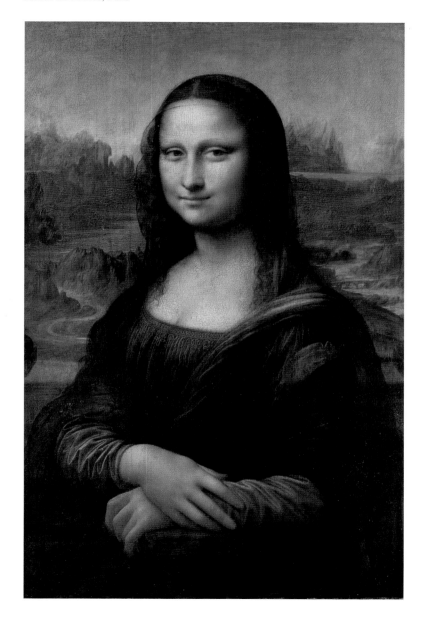

Family tree of Lisa Gherardini,
fifteenth century

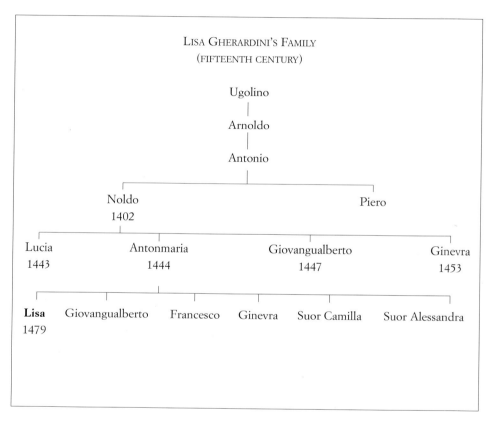

LISA GHERARDINI'S FAMILY
(FIFTEENTH CENTURY)

Ugolino

Arnoldo

Antonio

Noldo
1402

Piero

Lucia
1443

Antonmaria
1444

Giovangualberto
1447

Ginevra
1453

Lisa
1479

Giovangualberto

Francesco

Ginevra

Suor Camilla

Suor Alessandra

The dates refer to the year of birth

Family tree of Francesco
del Giocondo, fourteenth century

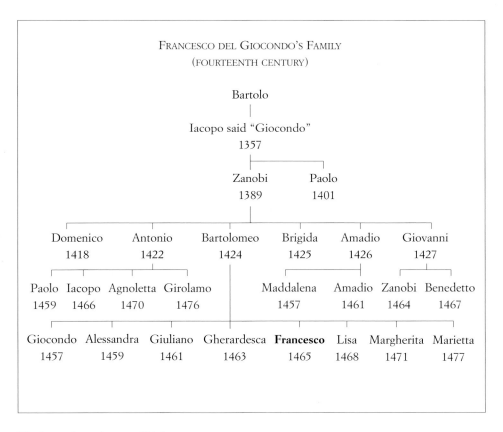

FRANCESCO DEL GIOCONDO'S FAMILY

(FOURTEENTH CENTURY)

Bartolo

Iacopo said "Giocondo"
1357

Zanobi Paolo
1389 1401

Domenico Antonio Bartolomeo Brigida Amadio Giovanni
1418 1422 1424 1425 1426 1427

Paolo Iacopo Agnoletta Girolamo Maddalena Amadio Zanobi Benedetto
1459 1466 1470 1476 1457 1461 1464 1467

Giocondo Alessandra Giuliano Gherardesca **Francesco** Lisa Margherita Marietta
1457 1459 1461 1463 1465 1468 1471 1477

The dates refer to the year of birth

III

Map of Florence, dated 1480
Museo Firenze com'era, Florence

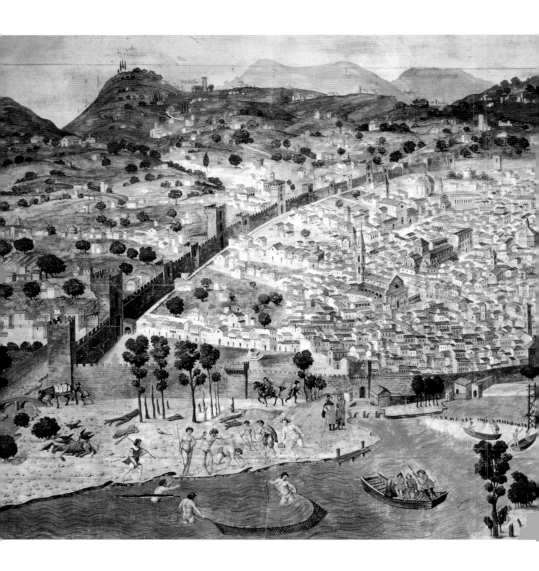

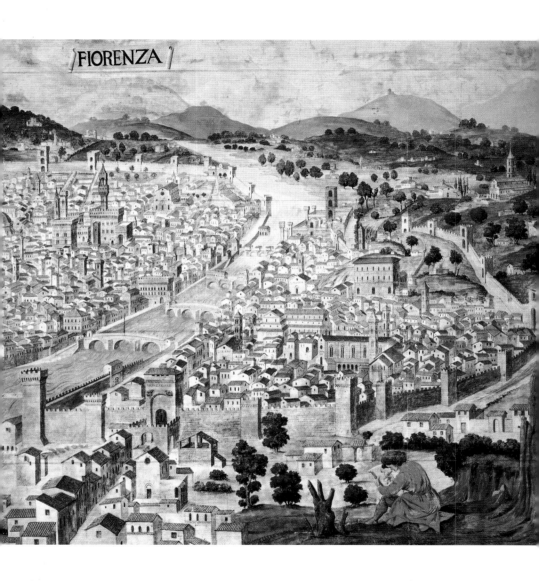

Plan of the farm Ca' di Pesa (1717), detail of the *casa da Signore e da lavoratore.* Archivio di Stato, Santa Maria Nuova 696, c. 52, Florence

Mona Lisa del Giocondo and the distillate of snail-water (1514). Convent of Sant'Orsola, Florence. Memoirs of Suor Felice, ministress of the Convent. Archivio di Stato, *Corporazioni religiose soppresse dal governo francese* 100, no. 89, book 5, Florence

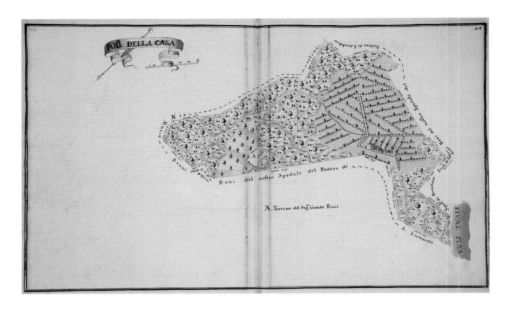

Detail of the plan of Ca' di Pesa (1717). Archivio di Stato, Santa Maria Nuova 696, c. 52, Florence

Io p m maddalena deguardi farò qui ricordo di tutti edanari chio riceverò
altempo delmio ministrato didoto difanciulle dilimosina e pigione
dilauorio adonorando lepartite disporò luna dallaltra cioè p
partita porrò edanari chio riceverò dilimosina diprima

addi z difebraio 1513 oricieuuto d 3 ß 10 plimosina dauno cittadino — d 3 ß 10 d
et addi 4 didò d 12 plimosina dalla signoria id ———————— d 12 ß d
et addi 11 didò orricieuuto ß 15 ƒ doro ytioro plimosina dafranciesco
dibandetto guardi ——————————————————————— ß 15 ƒ
et lire 11 ß 3 ouuto plimosina p far una piatanza alle suore dami dicll
ra dona fu difrefano dacll ——————————————— d 11 ß 3 d
et addi 11 dimarzo 1513 oricieuuto ß q ƒ doro ytioro dalla dco mona
diustra pchonto deluito didua mesi aragione di ß 2 ƒ doro ytioro
olmoze bitzor addi 8 difebbraio 151q sicht sono pagoua pinsino
addi 8 daprile 151q —————————————————— d 28 ß d
et addi 8 daprile 151q orrieieuuto d 12 plimosina dalla signoria d 12 ß d
et addi 6 didò d 13 pchonto dilimosina chosa disponsare elco podre d 13
et lire 7 ouuto dauna dona plimosina pchio glifaci dire eposterno tri
disca orsola echosi glidiß io dire ————————————— d 7 ß d
et lire 7 orricieuuto dalla sopra dco m diustra pchonto deluito duno meza
mese ———————————————————————————— d 7 ß d
et piu foricordo chome addi — 23 dimarzo ricieuti 3 ß 10 danisbalo
dalla palla plimosina —————————————————— d 3 ß 10 d
et addi 12 daprile 151q orricieuuto d 3 ß 10 daldco nichelo dalla palla d 3 ß 10 d
et addi 15 didò orricieuuto d 5 dallorenzo lapi plimosina — d 5 ß d
et addi 20 dimaggio 151q ouuto d 7 plimosina da m d inbura chefu dona
di benci ———————————————————— d 7 ß d
et addi 27 didò oricieuuto d 12 plimosina dalla signoria — d 12 ß d
et addi uimo didò orricieuuto d 3 ß 10 danichelo dalla palla plimosina d 3 ß 10 d
et addi 15 digiugio 151q ouuto d 5 dagiouanfranciesco dcrocicorß plimos d 5 ß d
et addi 10 dagosto 151q ouuto d 3 ß 10 danichelo dalla palla plimosina d 3 ß 10 d
et addi 11 didò d 3 damona lisa delgiocondo plimosina ——— d 3 ß d
et addi 22 didò ouuto d 12 plimosina dalla signoria ——— d 12 ß d
et addi 29 didò ouuto d 7 damona lisa delgiocondo pisillio e aqua dioioro
le calue cose della violetanci ———————————————— d 7 ß d
et addi 30 didò ouuto d q dabartolinto buandelmonti plimosina d q ß d
et lire 3 ß 3 ouuta da s girolama p pagare laqua della porretta
della apighare ——————————————————————— d 3 ß 3 d
et addi 13 disettembre 151q ouuto d q ß q da sandrea bechia pchon
to duna sua nipote chocia attarò qualche setimana ——— d q ß q
 ß 35 ƒ

Will made by Francesco
di Bartolomeo del Giocondo
(29 January 1537).
Archivio di Stato, *Notarile*
antecosimiano 7799, c. 6v, Florence

Notes

Florence during the Renaissance

[1] *Firenze Rinascimentale*, Giunti, Florence 1978, pp. 25–36; H. van Werveke, "La nascita delle città", in *Storia economica Cambridge*, Vol. III, Einaudi, Turin 1977, pp. 44–45.

[2] R. Romano, "La storia economica", in *Storia d'Italia*, II, pp. 1826–27, Einaudi, Turin 1974; C. Vivanti, "La storia politica e sociale", in *Storia d'Italia*, cit., Vol. II, pp. 284 ff.

[3] On the families and population in Florence in the fifteenth century, cfr. Herlihy-Klapish Zuber, *I Toscani e le loro famiglie. Uno studio sul Catasto fiorentino del 1427*, Il Mulino, Bologna 1988.

[4] On the Ciompi revolution, cfr. G. Brucker, "The Ciompi revolution", in *Florentine Studies*, edited by N. Rubinstein, London 1968, pp. 314 ff.; V. Rutenburg, *Popolo e movimenti popolari in Italia nel '300 e '400*, Il Mulino, Bologna 1971, pp. 344 ff.

[5] P. Renucci, "La cultura", in *Storia d'Italia*, cit., Vol. II, pp. 1240–64.

[6] *Firenze Rinascimentale*, cit., pp. 7–24.

[7] For an overall view on the artists of Florence in the early Quattrocento, see *Firenze Rinascimentale*, cit., pp. 270–90.

[8] On this, see P. Jones, "Economia e società nell'Italia feudale", in *Storia d'Italia*, cit., Annali, I, p. 345.

[9] For a summary of the history of Florence from the Middle Ages, see F. Cardini, *Breve storia di Firenze*, Pacini Editore, Pisa 2000.

[10] This percentage grew notably later on: in the sixteenth and seventeenth centuries the Church's proportion grew to almost 40% of all landed property in Tuscany.

[11] Cardini, *Breve storia di Firenze*, cit., pp. 91 ff.

[12] *Ivi*, p. 95.

[13] On private life in Tuscany in the Quattrocento, see C. de La Roncière, "La vita privata dei notabili toscani alle soglie del Rinascimento", in *La Vita privata dal Feudalesimo al Rinascimento*, Laterza, Bari 1988, pp. 130–251; on the family and the women's role, see *Firenze Rinascimentale*, cit., pp. 85–104.

[14] On the dynamism of the economy and, in particular, the construction sector in Florence in the fifteenth century, see R. Goldthwaite, *La costruzione della Firenze rinascimentale*, Il Mulino, Bologna 1988.

[15] ASF (Archivio di Stato di Firenze), *Ufficiali dell'Onestà* 2. In May 1510 even Niccolò Machiavelli was accused of sexual violence but was freed and the subject hushed up due to the importance of his public office. ASF, *Otto di Guardia* 145, c. 17v.

[16] ASF, *Otto di Guardia* 147, c. 119.

[17] On this, see the two series, *Cause civili* and *Cause criminali* in the Archivio Arcivescovile in Florence, which contain the documents of trials against prelates held in the Tribunale della Curia vescovile in Florence.

[18] ASF, *Otto di Guardia e Balia* 22, c. 4.

[19] *Ibid.*, 229, cc. 5 ff.

[20] *Ibid.*, 229, cc. 43 and 95.

[21] *Ibid.*, 231, c. 2v.

[22] *Ibid.*, 229, cc. 5, 39, 42, 43 and 84.

[23] B. Dei, *La Cronica*, edited by Roberto Barducci, Francesco Papafava Editore, Florence 1984, pp. 84–85.

[24] On the fall of the Medici and the flight of Piero, see *Firenze Rinascimentale*,

cit., pp. 189–200.

[25] On this see Diaz, "Il granducato di Toscana", in *Storia d'Italia*, Utet, Turin 1976, p. 8.

[26] Machiavelli was born in Florence in 1469 and was a member of a minor branch of the Florentine family. The main branch owned a sizeable landed estate, including several hotels on the other side of the Arno. Little is known of Niccolò's youth; it seems he undertook humanistic studies but without great success. Before he was even thirty, he was appointed Segretario della Signoria in June 1498, an office that dealt with internal affairs, war and the military organization of the State.

[27] On the vicissitudes of the Medici in the early Cinquecento, see Diaz, *Il Granducato di Toscana*, cit., pp. 10 ff.

[28] On the reforms introduced by Cosimo I, see *ivi*, pp. 85–108.

[29] *Ivi*, pp. 109 ff.

[30] G. Vasari, *Le vite de' più eccellenti architetti, pittori, et scultori italiani, da Cimabue insino a tempi nostri* (Florence 1550), Turin, 1986. The revised and expanded second edition of the *Lives* was published in Florence in 1568.

The Gherardini family

[1] AOSMF (Archivio dell'Opera di Santa Maria del Fiore di Firenze),

Battesimi 1475–81, c. 97.

[2] The Corbinelli family were the lords of Oltrarno and had various palazzi in Via Maggio. In the mid-Cinquecento one of these was bought by Grand Duke Francesco I who, without worrying about costs, turned it into the magnificent residence of the Venetian Bianca Cappello, first his lover and from 1579 his wife. This event aroused hatred and rivalry in the court that did not abate until their deaths, which by chance occurred on the same day, 20 October 1587. Francesco died early in the morning, Bianca at 3 pm. She was immediately, though unjustly, suspected of having poisoned her husband (Diaz, *Il Granducato di Toscana*, cit., p. 239).

[3] ASF, *Carte Sebregondi* 2608.

[4] The Del Caccia family were lords of the Val di Greve from the Middle Ages. For centuries they owned Colognole Castle, which stands at the top of a hill and at the center of a heavily wooded landscape (perhaps their name is derived from the hunting activity of their ancestors [*caccia* is the Italian word for "hunt", *translator's note*]. Further down, along the river Greve, Galeotto owned four farms, a *casa da Signore* and workers' accommodation called La Calcinaia, which he sold in

1524 to the Counts Capponi of Florence. They later enlarged it and made it into one of the loveliest villas in Chianti.

[5] ASF, *Catasto* 1007, c. 301.

[6] *Ibid.*, 68, c. 211.

[7] ASF, *Gherardi* 324, c. 4.

[8] Besides the houses and lands in Cortine, Noldo and Piero owned other properties in the area: a house with vineyards in San Giorgio, a mill with vegetable garden on the Argiena torrent, and a small farmhouse between Chianti and Valdarno. ASF, *Catasto* 68, cc. 264–65.

[9] *Ibid.*, 813, c. 444.

[10] *Ibid.*, c. 445.

[11] *Ibid.*, 918, c. 174.

[12] *Ibid.*, 1009, c. 4.

[13] *Ibid.*, 1009, c. 3.

[14] ASF, *Santa Maria Nuova* 5745, c. 178.

[15] *Ibid.*, 583, c. 166.

[16] *Ibid.*, 5745, c. 178.

[17] ASF, *Notarile antecosimiano* 17151, c. 484.

[18] ASF, *Carte Sebregondi* 2608.

[19] ASF, *Catasto* 915, c. 437.

[20] ASF, *Decima repubblicana* 17, c. 78.

[21] ASF, *Corporazioni religiose soppresse dal governo francese* 78, no. 79, c. 134

[22] ASF, *Decima repubblicana* 20, c. 26v.

[23] At that time Michelangelo was in Rome working for the pope. He insisted on being paid well and sent much of his handsome earnings to his current account at Santa Maria Nuova in Florence, the

institute that, in addition to
helping the sick, was one of
the largest financial centers
in the city. He collected
money by holding current
accounts and owned
an enormous amount
of property that offered
excellent guarantees
to its savers.

The Giocondo family

[1] AOSMF, *Battesimi*
1460–66, c. 123.
[2] ASF, *Catasto* 79,
cc. 290–92.
[3] *Ibid.*, 1015, c. 10.
[4] *Ibid.*, 79, c. 291.
[5] *Ibid.*, 923, c. 54.
[6] *Ivi.*
[7] *Ibid.*, 820, c. 338.
[8] *Ibid.*, 1015, c. 11.
[9] *Ibid.*, 923, c. 54.
[10] *Ibid.*, 1015, c. 10.
[11] Innocenti (Archivio
Storico dell'Ospedale degli
Innocenti), *Estranei* 409,
c. 7.
[12] *Ibid.*, cc. 21, 27, 34, 47, 64.
[13] *Ibid.*, c. 42.
[14] *Ibid.*, 532, c. 10.
[15] *Ibid.*, c. 3.
[16] ASF, *Decima repubblicana*
28, cc. 407–408.

Lisa and Francesco's marriage

[1] For all, see F. Zollner,
*Leonardo da Vinci, Mona
Lisa*, Frankfurt 1994. Of the
three marriages, the second
seems very improbable
because Francesco was
always referred to as the
husband of Camilla Rucellai
in the registers of the Monte
delle Doti in 1493 and 1494.
ASF, *Monte comune* 1397,

cc. 32v e 63v.
[2] ASF, *Ufficiali di Grascia*
190, c. 241.
[3] ASF, *Catasto* 820, c. 340.
[4] ASF, *Catasto* 1012, c. 126.
[5] AOSMF, *Battesimi*
1474–81, c. 21v.
[6] ASF, *Monte comune* 1397,
c. 63v.
[7] AOSMF, *Battesimi*
(maschi) 1492–1501, c. 72v.
[8] ASF, *Ufficiali di Grascia*
190, c. 241.
[9] ASF, *Notarile
antecosimiano* 10584.
[10] See L. Fabbri, *Alleanza
matrimoniale e patriziato
nella Firenze del '400*,
Olschki, Florence 1991,
p. 19.
[11] Innocenti, *Estranei* 410,
cc. 12, 14, 17.
[12] AOSMF, *Battesimi*
(maschi) 1491–1501, c. 51.
[13] AOSMF, *Battesimi*
(femmine) 1491–1501,
c. 273.
[14] Innocenti, *Estranei* 404,
c. 82.
[15] M. King, "La donna del
Rinascimento", in *L'uomo
del Rinascimento*, Laterza,
Bari 1988, pp. 281 ff.
[16] AOSMF, *Battesimi*
1502–11, c. 17.
[17] *Ibid.* c. 100v.
[18] Unlike the other children,
the year of Marietta's birth
is not known.
[19] ASF, *Notarile
antecosimiano* 7799, c. 268.
[20] *Ibid.*, 17147, c. 440.
The convent was called
San Domenico di Cafaggio.
Cafaggio was the ancient
name of the countryside to
the east of Florence, and lay
between San Marco, the

Santissima Annunziata and
the city walls. Its name was
later changed to San
Domenico nel Maglio.
[21] ASF, *Otto di Guardia* 152,
c. 173v. The reports were
often about sexual violence,
such as acts of sodomy, rape,
incest and violence on
children. In 1510 even
Bartolomeo—Francesco del
Giocondo's first son—was
accused of sodomy on a
certain Piero who, as was
written, "often allowed
himself to be embraced like
a whore". ASF, *Otto di
Guardia* 147, c. 119.
[22] ASF, *Corporazioni religiose
soppresse* 100, no. 89,
book 4.
[23] *Ibid.*, no. 51, c. 32.
[24] *Ibid.*, no. 89, book 5.
[25] *Ibid.*, no. 51, c. 11
[26] ASF, *Notarile
antecosimiano* 17151,
cc. 484–86.
[27] *Ibid.*, 17146, cc. 150–51.
[28] *Ibid.* c. 160.
[29] ASF, *Otto di Guardia* 147,
cc. 19–20.
[30] ASF, *Mediceo Avanti
il Principato*, III, file 85,
no. 487. In 1525 Francesco
del Giocondo was in Lyons
where he wrote a business
letter to Rome. The date of
the letter is 1 April 1525.
[31] ASF, *Corporazioni religiose
soppresse* 119, no. 50,
c. 109v.
[32] Archivio Arcivescovile di
Firenze, *Cause Civili*, no.
268 f. 3, no. 67 f. 10.
[33] ASF, *Notarile
antecosimiano* 17148, c. 298.
[34] ASF, *Santa Maria Nuova*
5745, c. 178.

[35] ASF, *Notarile antecosimiano* 17147, c. 141.

[36] *Ibid.*, 17148, c. 298.

[37] *Ibid.*, 17150, c. 130.

[38] ASF, *Decima granducale* 3611, c. 162 v.

[39] *Ibid.*, c. 164.

[40] *Ibid.*, 3629, cc. 351–52.

[41] *Ibid.* cc. 353–54.

[42] ASF, *Notarile antecosimiano* 7799, cc. 5–8.

[43] Martyrs' chapel is the fourth on the right in the apse of the Santissima Annunziata. Beneath the small stone altar, a stone records the ancient name as follows: "sacellum hoc olim ss. martyrum ac seraphici patris culti dicatum" (chapel once dedicated to the worship of the Holy Fathers and Most Holy Martyrs).

[44] ASF, *Notarile antecosimiano* 7799, c. 6.

[45] The exact day of Francesco's death is uncertain: a notarial document refers to March 1538 (ASF, *Notarile antecosimiano* 6689, c. 77v); in the list of deaths held in the Santissima Annunziata the burial was recorded on 8 June 1538 (ASF, *Corporazioni religiose soppresse* 119, no. 50, c. 77).

[46] ASF, *Notarile antecosimiano* 6689, cc. 287–88.

[47] *Ibid.*, c. 291.

[48] ASF, *Corporazioni religiose soppresse* 100, no. 89, book 5.

[49] ASF, *Mercanzia* 10959.

Mona Lisa and her identity

[1] Vasari, *Le vite dei più eccellenti architetti, pittori et scultori italiani da Cimabue insino a' tempi nostri* (Florence 1550), Einaudi, Turin 1991, p. 552.

[2] *Ivi.*

[3] D. Sassoon, *La Gioconda*, Carocci, Rome 2002, p. 38.

[4] C. Pedretti, "Gioconda in volo", in P. Marani, *Leonardo. La Gioconda*, Giunti, Florence 2003, pp. 4–5; Sassoon, *La Gioconda* cit., p. 39.

[5] On the theft of the painting, see Marani, *La Gioconda*, cit., pp. 18–19 and Sassoon, *La Gioconda*, cit., pp. 176–78.

[6] Marani, *La Gioconda*, cit., pp. 24, 44.

[7] C. Scailliérez, *La Joconde*, Louvre, Paris 2003, p. 17.

[8] Sassoon, *La Gioconda*, cit., pp. 2, 167–68.

[9] This hypothesis is not totally far-fetched seeing that Lisa had at least three children at the start of the Cinquecento.

[10] Sassoon, *La Gioconda*, cit., pp. 31–32.

[11] ASF, *Notarile antecosimiano* 16912, c. 105v.

[12] AOSMF, *Battesimi* 1460–66, c. 76v.

[13] E. Crispino, *Leonardo*. Giunti, Florence 2002, pp. 10–11; *Leonardo da Vinci. La vera immagine*, Giunti, Florence 2005, p. 120.

[14] ASF, *Notarile antecosimiano* 7399, c. 52 ss.

[15] Leonardo did not speak of love in the general or abstract sense, he referred to it as the perceptible experience of the conjugal relationship. For him the true source of human life is not so much fertilization as the great love and desire of the two parties. Only the passion of the couple, followed by the joy of the expectant mother, will give the child a great intellect, wittiness, liveliness and tenderness, as he wrote in the Weimar Sheet.

[16] Vasari, *Le vite*, cit., p. 551.

[17] As the accounts of Santa Maria Nuova indicate, Leonardo made the following withdrawals. In 1503: on 4 March, 14 June, 1 September and 21 November (on each occasion he withdrew 50 florins). In 1504: on 27 April (50 florins). In 1505: on 24 February (25 florins) and 15 April (25 florins). In 1506: on 20 May (50 florins). ASF, *Santa Maria Nuova* 5638, c. 266.

[18] *Leonardo da Vinci. La vera immagine*, cit., p. 188. The artist noted the event as follows: "Day of 9 July 1504, Wednesday at 7 o'clock, Piero da Vinci died, notary to the Palazzo del Podestà, my father at 7 o'clock. He was 80 years old he left ten sons and two daughters". *Leonardo. La vera immagine*, cit., p. 202.

[19] According to some experts, Leonardo began the work a full ten years later. For this hypothesis,

see Crispino, *Leonardo*, cit., pp. 96 ff.

[20] For example, he knew that Mariano was the friar who, at the beginning of the century, had his position at the candle counter in the church of the Annunziata and that it was he—with money in his hand—who convinced Andrea del Sarto to fresco the entrance cloister by showing him the day's takings (Vasari, *Le vite*, cit., p. 699; the episode is confirmed in a book of friars' memoirs, ASF, *Corporazioni religiose soppresse* 119, no. 59). Vasari was also well aware of the story of the high altar, which was first commissioned from Filippino Lippi, then from Leonardo, and finally from Perugino (Vasari, *Le vite*, cit., pp. 534, 551. Vasari's version corresponds exactly with the one written by the friars in the book of their memoirs mentioned above).

[21] In April 1503, Francesco purchased a house close to his own in Via della Stufa and a year later bought another in Via della Scala, paying almost 500 florins in total. ASF. *Notarile antecosimiano* 17146, cc. 160, 402.

[22] Vasari, *Le vite*, cit., p. 552.

[23] When in 1494 Camilla Rucellai, Francesco's first wife, died, her name tended to be overshadowed by that of her husband, and on the death certificate she was not

recorded as Camilla Rucellai but as "the woman of Francesco del Giocondo". This is proof that the young merchant had already achieved a certain fame. ASF, *Ufficiali di Grascia* 190, c. 241.

[24] ASF, *Notarile antecosimiano* 16837, c. 279v.

[25] *Ibid.*, 16833, c. 535v; *Ibid.*, 16834, c. 413.

[26] As has already been said, in 1642 father Pierre Dan referred to Francesco del Giocondo as an intimate friend of Leonardo; see Marani, *La Gioconda*, cit., p. 46.

[27] ASF, *Corporazioni religiose soppresse* 119, no. 50, c. 77.

[28] Leonardo del Giocondo and his son Piero are mentioned by Vasari in the pages on Andrea del Sarto because their house contained a beautiful Madonna by the artist. Vasari, *Le Vite*, cit., p. 702.

[29] ASF, *Corporazioni religiose soppresse* 119, no. 59, c. 17v.

[30] Vasari, *Le Vite*, p. 658.

[31] ASF, *Accademia del Disegno* 24, c. 5. Giorgio Vasari was very well known at the Annunziata. He was a regular visitor to the church and monastery as a man of faith and member of the Accademia del Disegno. He also painted the fresco in the chapel of the Compagnia di San Luca, beside the presbytery. The existence of this close link seems confirmed by another fact, the affluence of monks

at the funeral of his mother which took place on 5 July 1558 in the church of Santa Croce in Florence.

[32] Vasari, *Le Vite de' più eccellenti pittori, scultori e architettori* (second edition, Florence 1568), Newton Compton, Rome 1991, p. 5.

[33] On the death of Piero del Giocondo, see ASF, *Decima granducale* 3628, c. 295; on the death of Suor Ludovica, see ASF, *Corporazioni religiose soppresse* 100, no. 90, book 17.

[34] ASF, *Arte della seta* 13, c. 54.

[35] ASF, *Corporazioni religiose soppresse* 119, no. 203, c. 1.

[36] On the basis of recent examinations, it is thought by some that the portrait was modified during its long period of execution, and that originally the face was without a veil, thinner in the cheeks and, above all, without her smile. M. Carminati, *Leonardo da Vinci. La Gioconda*, Silvana Editoriale, Milan 2003, p. 11.

[37] V. Sgarbi, *Da Giotto a Picasso*, Rizzoli, Milan 2002, pp. 89–90.

Selected bibliography

On the history of Florence in the Quattrocento and Cinquecento

G. Brucker, *Firenze nel Rinascimento*, La Nuova Italia, Florence 1980.

G. Brucker, *Dal Comune alla Signoria. La vita pubblica a Firenze nel Rinascimento*, Il Mulino, Bologna 1981.

F. Cardini, *Breve storia di Firenze*, Pacini Editore, Pisa 2000.

G. Cherubini, *Signori, contadini e borghesi nell'Italia del basso medioevo*, La Nuova Italia, Florence 1974.

C.M. Cipolla, *Storia dell'Europa preindustriale*, Il Mulino, Bologna 1974.

C.M. Cipolla, *I pidocchi e il Granduca*, Il Mulino, Bologna 1979.

C.M. Cipolla, *La moneta a Firenze nel Cinquecento*, Il Mulino, Bologna 1987.

C.M. Cipolla, *Tre storie extra vaganti*, Il Mulino, Bologna 1994.

R. De Roover, *Il Banco Medici dalle origini al declino, 1397-1494*, La Nuova Italia, Florence 1970.

B. Dei, *La Cronica*, edited by R. Barducci, Papafava Editore, Florence 1984.

F. Diaz, *Il Granducato di Toscana*, UTET, Turin 1976.

L. Fabbri, *Alleanza matrimoniale e patriziato nella Firenze del '400*, Olschki, Florence 1991.

Firenze rinascimentale, Giunti, Florence 1978.

R. Goldthwaite, *La costruzione della Firenze rinascimentale*, Il Mulino, Bologna 1974.

Herlihy-Klapish Zuber, *I Toscani e le loro famiglie. Uno studio sul Catasto fiorentino del 1427*, Il Mulino, Bologna 1988.

C. de La Roncière, *Florence centre économique regional au XIVe siecle*, Aix-en-Provence 1978.

D. Lombardi, *Matrimoni di antico regime*, Il Mulino, Bologna 2001.

L'uomo del Rinascimento, Laterza, Bari 1988.

A. Molho, *Florentine Public Finances in the Early Renaissance, 1400–1433*, Cambridge, MA, 1971.

A. Molho, *Marriage alliance in late Medieval Florence*, Cambridge, MA, 1994.

G. Pinto, *La Toscana nel tardo Medioevo*, Florence 1982.

N. Rubinstein, *Il Governo di Firenze sotto i Medici*, La Nuova Italia, Florence 1971.

On the history of art, Leonardo's works and the painting of La Gioconda

G.C. Argan, *Storia dell'arte italiana*, Sansoni, Florence, 1997.

L.M. Batkin, *Leonardo da Vinci*, Laterza, Bari 1988.

Bertelli, Briganti, Giuliano, *Storia dell'arte italiana*, Electa–Mondadori, Milan 1986.

Bora, Fiaccadori, Negri, Nova, *I luoghi dell'arte*, Electa-Bruno Mondadori, Milan 2003.

J. Burckhardt, *La civiltà del Rinascimento in Italia*, Sansoni, Florence 1984.

M. Carminati, *Leonardo da Vinci. La Gioconda*, Silvana Editoriale, Milan 2003.

A. Chastel, *Arte e Umanesimo a Firenze al tempo di Lorenzo il Magnifico*, Einaudi, Turin 1964.

A. Chastel, *La Gioconda, l'illustre incompresa*, Edizioni Leonardo, Milan 1989.

A. Chastel, *Un Cardinale del Rinascimento in viaggio per l'Europa*, Laterza, Bari 1995.

K. Clark, *Leonardo da Vinci. Storia della sua evoluzione artistica*, Mondadori, Milan 1983.

E. Crispino, *Leonardo*, Giunti, Florence 2002.

E. Gombrich, *La storia dell'arte raccontata da E. Gombrich*, Einaudi, Turin 1966.

E. Gombrich, *Antichi maestri, nuove letture: studi sull'arte del Rinascimento*, Einaudi, Turin 1987.

M. Kemp, *Leonardo da Vinci: le mirabili operazioni della natura e dell'uomo*, Mondadori, Milan 1982.

Leonardo da Vinci. La vera immagine, exhibition catalogue, Giunti, Florence 2005.

Leonardo da Vinci, *Trattato della pittura*, Neri Pozza, Vicenza 2000.

Leonardo, edited by Chastel, Galluzzi, Pedretti, Giunti, Florence 1987.

P. La Mure, *Vita privata di Monna Lisa*, Rizzoli, Milan 1978.

P. Mariani, *Leonardo. La Gioconda*, Giunti, Florence 2003.

R. McMullen, *Mona Lisa. The Picture and the Myth*, Houghton Mifflin Company, Boston 1975.

C. Pedretti, *Leonardo. A Study in Chronology and Style*, Thames and Hudson, London 1973.

D. Sassoon, *La Gioconda*, Carocci, Rome 2002.

C. Scaillièrez, *Leonardo da Vinci. La Joconde*, Réunion des Musées Nationaux, Louvre, Paris 2003.

V. Sgarbi, *Da Giotto a Picasso*, Rizzoli, Milan 2002.

G. Vasari, *Le vite de' più eccellenti architetti, pittori et scultori italiani da Cimabue insino a' tempi nostri* (Florence 1550), Einaudi, Turin 1991.

G. Vasari, *Le vite de' più eccellenti pittori, scultori e architettori* (second edition, with the addition of the lives of living and dead artists from 1550 to 1567, Florence 1568), Newton Compton, Rome 1991; English ed.: *Lives of the Painters, Sculptors and Architects*, translated by G. de Vere, 10 Vols., Everyman, London 1996.

C. Vecce, *Leonardo*, Salerno editrice, Rome 1998.

R. Villa, *Leonardo*, Mondadori, Milan 1991.

F. Zollner, *Leonardo da Vinci, Mona Lisa. Das Portrat der Lisa del Giocondo. Legende und Geschichte*, Frankfurt 1994.